www.danielway.com

ALL IN A DAY'S WORK

To Bert Bell MD:
For those times when you wish
you could be one of the
Turner Brothers!
(Read on........)

Daniel Way MD

I have two professions and not one. Medicine is my lawful wife and literature is my mistress. When I get tired of one, I spend the night with the other. Though it's disorderly, it's not so dull and besides, neither loses anything through my infidelity.

—Anton Chekhov, *Russian physician and playwright*

ALL IN A DAY'S WORK

*Scenes and Stories from an
Adirondack Medical Practice*

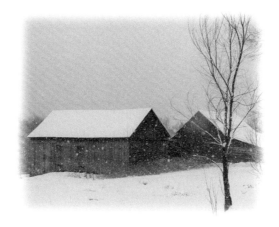

Daniel Way, M.D.

With a Foreword by John Rugge, M.D.

SYRACUSE UNIVERSITY PRESS

NORTH CREEK RAILWAY DEPOT PRESERVATION ASSOCIATION

Syracuse University Press
Syracuse, New York 13244-5160

First Edition 2004
04 05 06 07 08 09 6 5 4 3 2 1

This book was published with the assistance of a grant
from Furthermore: a program of the J. M. Kaplan Fund.

Library of Congress Cataloging-in-Publication Data
Way, Daniel.
 All in a day's work : scenes and stories from an Adirondack
medical practice / Daniel Way, with a foreword by John
Rugge.— 1st ed.
 p. cm.
 Includes bibliographical references.
 ISBN 0-8156-0801-2 (hardcover (cloth) : alk. paper)
 1. Medicine, Rural—New York (State).—Adirondack
Mountains. 2. Hudson Headwaters Health Network.
3. Way, Daniel. I. Title.
R291.W29 2004
362.1'04257'097475—dc22 2004004970

The paper used in this publication meets the minimum
requirements of American National Standard for
Information Sciences—Permanence of Paper for Printed
Library Materials, ANSI Z39.48-1984.∞™

Printed in Canada

DANIEL WAY, M.D., a native of Glens Falls, began
taking pictures at the age of eleven and had already
developed a passion for the art long before begin-
ning his career in family medicine for the Hudson
Headwaters Health Network, which serves the
entire southeastern Adirondacks.

CONTENTS

FOREWORD

John Rugge, M.D.

First, a few disclaimers. Dan Way is my partner and he is my friend. Also, I have long encouraged him to undertake this project. Therefore, anything I might have to say here should be taken with a good dose of salt. I rightly can be considered prejudiced in the book's favor, and (even worse) I know that I may be subject to retaliation if my remarks are not flattering in ample proportions.

Fortunately, I have no need to worry. Dan's work speaks for itself with such power and eloquence that no praise is necessary to promote it and no errant criticism at this point could diminish its value.

Let me say a few words about the photographer and the author. Like most country doctors, Dr. Way is a public figure—in his case not in one but in two of our mountain towns, North Creek and Indian Lake. He is a universally admired person with an enormous reputation both for his professional skill and for his availability. By availability, I mean that he gives all his patients all the time and all the attention they need, no matter how complicated the problem or how humble their own circumstances. Long before he thought to take his camera along, he followed his patients everywhere—into ambulances, the hospital, nearby nursing facilities, and, yes, into their own homes. For more than twenty years he has become the kind of doctor about whom patients like to say, "He is able to take one look at me and know what's wrong."

As it turns out, Dan looks at people, many of them his patients, in a way that few physicians do—through a viewfinder. As he makes clear in his introductory essay, photography is in his genes, although in his particular case the genes of Seneca Ray Stod-dard had to jump a branch in the family tree (through marriage) to get to him.

For ten years and more, Dan followed his Great Uncle Ray's example and captured on film the modern Adirondack landscape. Thanks in part to its isolation, a general lack of development, and, by implication, an abundance of indigenous poverty as well as important constitutional protections, this landscape still looks much the same as it did in Stoddard's day. Thanks to technology, of course, the images are different; for example, they are now in color, shades sometimes vibrant and sometimes subtle.

Few people (not I) have seen all the pictures that Dan has discarded. In that pile, which is presumably enormous, lie all the lessons he has learned about photographic technique and how to create a signature style so pure and so transparent as to appear totally, well, natural. Dan's landscapes put the viewer right there—in the middle of beautiful country where morning mist rises ever so gently on the river, where old farmhouses settle just a bit lopsidedly on even more ancient foundations, where the occasional guideboat slips through the surface of a pond breaking its glassy veneer as it goes. Dan Way does what Seneca Ray would have done if Mr. Eastman had only been there for him.

But the real magic came next. It was, as I recall, prompted by the need to show a certain federal official why a fledgling Health Network called Hudson Headwaters needed a certain government grant. "Dan," I said, "Do you think you could take a few shots of our patients?" The results were riveting and I still carry a file of those originals when I travel to Washington.

Notwithstanding Chinese proverbs about the right ratio of pictures to words, Dan's portraits work in ways beyond counting. I am unable to describe to any satisfaction just how he achieves what he does. There is, I suspect, a special alchemy involving emulsions and shutter speed and the peculiar luminescence cast by portable goose lamps appropriated from the labor unit at the Glens Falls Hospital.

More fascinating is the chemistry that ignites between subject and object, person and photographer, and, in this instance, patient and doctor. Defining this process eludes me too, much as I find it impossible to understand connoisseurs averring to nose, body, and finish in appraising a fine wine. All the same, it is clear that something special is going on.

It seems best to sneak up on Dan's particular talent by looking at the work of others. Certain comparisons are all too obvious—Walker Evans, for example. Dan Way's photography could well be seen as a shoot off Evans's older Appalachian tree. Evans and his writing partner, James Agee, were after all under contract by the federal government to document the conditions of certain people—a mountain people—in need. It was the Farm Security Bureau that commissioned *Now Let Us Praise Famous Men.* Fifty years later, Way's work was undertaken to impress the Health Services Resources Administration. It's a big government.

Geologically, as it happens, the Adirondacks are the northernmost outpost along the Appalachian Range. And culturally the people are related too but still are not the same. The eyes staring out of Evans's pages burn with determination just to survive amidst absolute destitution. Theirs is the Great Depression incarnate.

Way's portraits belong to a later generation, and times have changed. There is much poverty and it can still be grinding. But his subjects find dignity through the choices they have made and the discipline they exercise in living as they do when other, easier alternatives—nursing home placement, for example—are very much available. In Way's gallery,

we see these people with their neighbors, some of whom live with evident pride in gracious settings. And, equally important, we see everyone in context, that is, in the mountain setting that helps shape the lives of all those who choose the Adirondacks as their home.

Adirondackers are, as we who count ourselves among them like to believe, a special breed. Not a breed apart but a breed *within* the rich mosaic that is America. Consider the photographic legacy left by Edward S. Curtis who spent decades furiously on the move, trying to capture the last of the tribes he knew as American Indians, the original Americans, before they disappeared. These souls in all their various attire and accoutrements appear with enormous dignity also and in their own high style. Yet students of Curtis have come to appreciate how many of his portraits were painstakingly posed to avoid the appearance of unwanted modern influences (power lines, for example) and in costumes that represent an intrusion of the artistic on the authentic.

Way's pictures are much more a come-as-you-are affair, freshly composed artifacts that catch life on the run just as it is. Yet, even now many of the people who have sat for him have already passed on and, with each passing, it seems that a bit of their world has become irretrievable, except through the photograph itself. The cumulative effect is to realize how quickly all these people, all of us, are passing through and how telling it will be to have this record of our way to leave for others.

Another photographer who comes to mind is the most audacious, one who makes me laugh. I think of the work of E. J. Bellocq in New Orleans at the turn of the twentieth century. His photographs were of the "girls" of Storyville, prostitutes in a rough, raucous river town. These were bad girls, outcasts all; yet in Bellocq's images, they appear gentle, even sweet, and so open and trusting that they too are full of dignity. The apparent connection among these young women to Bellocq was that he

was a hydrocephalic and therefore deformed in appearance and, by that virtue, a fellow outcast.

Make no bones, Dan Way has a totally normal head. The point is that he too has found an amazing and rewarding connection to his subjects. He is, as he is well aware, their doctor, the one they trust with their problems, their confidences and, when the chips are down, with their very lives. Of course they trust him, and he has the good grace to show these people as they are, as they really are. They appear to us every bit as natural and unassuming and full of themselves as the mountains that he also likes to shoot.

Of course, we know better. We know that he applies to all these shots the same technical legerdemain that he has learned and refined and, in some fashion, invented in these same mountains in order to proudly show to the world the people that he cares for.

Some time ago, our Health Network completed a renovation of one of our health centers, our largest facility located in Warrensburg. At the last minute,

someone suggested that we select a picture by Dr. Way for each of our new exam rooms. I was hesitant, concerned that some of these subjects, despite the signed release and all that, might be offended or feel unduly exposed. But we went ahead with the hangings anyway. A couple of weeks later, Ted Kaufmann, the North River dowser, came for a checkup and, by chance, he was escorted to the room that contained his picture. When I entered the room, I found him sitting on the examination table, big tears rolling down both cheeks. That experience was several years ago and he has since died, but his picture is still there.

In these pages, Dr. Way gives his patients exactly what they know to expect from him—a good look. In addition, he supplies text, letting us know how he has come to do this work, what it means to him, and a thing or two about the people who appear. Look closely, read carefully, and see if you agree with me: *All in a Day's Work* deserves to become a classic as the best-ever showcase of that remarkable sub-sub-species, *Homo sapiens americanus adirondackus.*

ACKNOWLEDGMENTS

The fact that I have been able to pursue my dream of publishing a book of photography for so many years is a tribute to the support of my wonderful family, including my very patient wife Harriet Busch, M.D., and my children Andrew and Emily. When they began to recognize that my goal was more than just an idle pipe dream, they displayed a remarkable combination of tolerance and resignation when I would make endless runs to the photo lab or make them stop on a hike while I set up my camera for a landscape. When I would take a particularly promising photo, Andy would ask, "Is it a *masterpiece?*" Certainly, the greatest masterpieces Harriet and I ever created are Andy and Emily. This project would mean nothing without my family's support.

My father taught me at a very young age how to use a camera and a darkroom, just as he himself learned as a boy. Because of his efforts, I was already developing my own film and printing black and white photographs at the age of twelve. His guidance and support ignited in me the passion for photography that has culminated in this project.

My mother's lifelong interest in the arts, including music, drawing, and painting, has had a great influence on my own appreciation for them as well. I hate to think of how dull life would be without the daily pleasures that they bring to my largely science-oriented existence. I also realize that she was a great influence in my decision to pursue a career in medicine. I think it started when she invited me to watch episodes of *Doctor Kildare* with her! I'm glad she did.

My big brother Dave, a journalism and photojournalism major at Syracuse University, has given me much inspiration to pursue my photographic hobby over the years. Now on the faculty at Cornell University, he knows more about digital photography and videography than I ever will. My big sister Anne Way Bernard is a professional artist in Boone's Mill, Virginia. I still treasure our memories of playing hooky together from high school in order to spend the day in nearby Philadelphia, where we would speak French all day while wandering the city. Our favorite destination was the Philadelphia Art Museum, and her devotion to art proved to be more contagious than I appreciated at the time.

In 1981, Dr. John Rugge offered me a job as a family physician in his then recently created rural health care system, the Hudson Headwaters Health Network. There I was expected to practice medicine in the most rural of the health centers in the southeastern Adirondacks. That offer changed my life in ways that I could only imagine at the time. The fact that he also was a twice-published author on a non-medical subject (canoeing) was a great source of inspiration to me.

The Arts Center at Old Forge, the Adirondack Lakes Center for the Arts, the Kirkland Art Center, the Lower Adirondack Regional Arts Council, the Saratoga County Arts Center, the North Creek Railway Depot Museum, and the New York State Council on the Arts have all given me very generous support over the years. They collectively made me feel that I really *could* publish a book some day if I set my mind to it.

Many people contributed by providing me with anecdotes, ideas for photographs, and other information that greatly enhanced the quality of this project. They include Jean Frasier, Carol Fosdick, Karen Andersson, Peggy Carroll, Angela Fremont, Beth Brown, Dick Purdue, Genevieve Davis, Kathy Pellatt, Captain Drew VanDerVolgen, among many others. The ADKO Color Lab in Glens Falls has provided me with excellent color processing for many years. Thanks, Adrian and Dave.

Mary Selden Evans and Mary Peterson Moore at Syracuse University Press, along with Alice Gilborn, former editor for the Adirondack Museum, are responsible for this book seeing the light of day. Alice's guidance and strong support, as well as her valuable experience in the world of publishing, allowed an amateur like me to make successful contact with the two Marys at SUP. I will always cherish my recollection of the enthusiasm they displayed on April 4, 2001, when I first presented my ideas to them. They had the vision and courage to preserve the content of *All in a Day's Work* in its original form, despite its nonconformity to traditional books of medicine and photography. John Rugge, Mathias Oppersdorff, Paula Bossert, and Bruce Cole were indispensable in reading the first draft and giving me needed guidance with the book's development.

One of the greatest pleasures in the development of this project was the participation of the people at the North Creek Railway Depot Preservation Association. Without their enthusiastic and unreserved support, you would not be holding this book in your hands. Mary Moro, Patricia Connor, Sterling Goodspeed, Lawrence Carr, and Sarah Valine gave me the opportunity to show my photographs at the North Creek Railway Depot Museum's Owens House gallery in the summer of 2002. The response to that show convinced them of the merit of this book, but their logistical, financial, and editorial support has been beyond my wildest expectations. Just thirty-two miles to the southeast of the Adirondack Museum in Blue Mountain Lake, the North Creek Railway Depot's museum, gallery, store, and vintage railroad is rapidly becoming an Adirondack destination with historical, artistic, and entertainment value in its own right.

Once the NCRDPA signed on as copublisher, they needed help from the community to finance their role as publisher. A spirited fund-raising campaign was initiated in the autumn of 2003, and several people and organizations stepped forward to ensure that the book's production was on solid financial ground. Ruth and Leonard Busch, Anne B. and Kevin J. Herlihy, Arlene and Peter Kien, Rebecca and Edward Milner, Margaret and Richard Purdue, Ruth and Thomas Soule, and the practice of Adirondack Orthopedic Physicians and Surgeons, PC, were especially instrumental. The fact that these and other kind and generous people had enough faith in my vision to invest in its creation has been a very humbling and satisfying experience. I hope the results meet expectations!

In addition to this grassroots support, the NCRDPA and I were honored by a generous grant from Furthermore, a program of the J. M. Kaplan Fund. Without this prestigious grant, we would probably still be looking for support. Instead, we have the backing of one of the most respected foundations in the country.

My office managers, nurses, aides, and fellow medical practitioners often put up with my breathless last minute arrivals at work, knowing without asking why I was later than expected. Often they would actually drive by me as I was capturing a scene from the shoulder of Route 28 on my way to or from work. At first they would honk their horns in recognition, but over the years they have come to consider it too commonplace to be worth a toot. Their support has meant a great deal to me over the years.

I also understand why people, when they enter a physician's office, are called "patients." Mine have had their patience tested to the maximum by the long wait to which I would often subject them. Over the years, I have noticed that, whereas they used to enter the waiting room empty-handed, and then with magazines as things got busier, they now come with books—big, thick ones. Instead of complaining, however, they would often repay me by allowing me to photograph them or by giving me tips on people or landscapes that I could photograph. I would, therefore, like to thank *all* of my patients, whether their images appear between these book covers or not. Perhaps I will leave a copy of this book in my waiting room, so they can at least read about themselves and the world they live in while I continue to keep them waiting!

VOCATION & AVOCATION

INTRODUCTION

All paid jobs absorb and degrade the mind
—Aristotle

I hope Aristotle was wrong. I have been practicing rural medicine in the Adirondack Mountains of upstate New York since 1981, and I must admit my mind has absorbed so much information that it seems every new fact that I cram into the front pushes some other fact that I used to know out the back unnoticed. In fact, just learning Aristotle's aphorism probably just caused me to forget some vitally important piece of medical knowledge, but I figure if such words of wisdom survived over two millennia, they must carry some weight. My work is intense and involves great responsibility, so I seek some words of comfort from the observations of others to justify the efforts I make. Thus, I also hope that the unknown person who said that "the amount of work to be done increases in proportion to the amount of work already completed" was wrong, since someone else once said that "at all times, for any task, you have not gotten enough done today." I prefer to believe the words of another wise man that stated that "if you love your job, you will never have to work another day in your life." However, on most days, my office staff and I are reminded of these words taken from an internet website devoted to aphorisms:

"A continuous flow of paper is sufficient to continue the flow of paper."

I have to admit I like my job. I enjoy practicing medicine, I enjoy driving through and working in the Adirondacks, and I also enjoy taking pictures. My work gives me the chance to do all three every day. It's not an easy job though; I leave my Glens Falls home at around 7:30 A.M., and I usually don't get home until between 6:30 and 8:00 P.M. In a normal week I commute about 440 miles, or 15,000 miles every year—300,000 miles in my career so far. I often drive through snowstorms and arctic cold, long after dark. So far I have hit three deer including one that shattered my windshield and dodged countless other wildlife including frogs, foxes, mink, raccoons, ravens, turkeys, bears, and an occasional moose. I have spun out on a North River road driving over black ice after a twelve-hour workday, saved from an unwelcome February dip in the Hudson River by a very well-placed guardrail that opened up the front end of my car like a sardine can. My Indian Lake office is over fifty miles from my Glens Falls home and the nearest hospital. The patient population I serve is a challenging one, with a high preponderance of seniors whose medical problems are complex and hard to manage in such a remote environment. Over the years, many physicians have considered these hardships an excellent reason to work elsewhere. Among the dozens of primary care physicians in the Hudson Headwaters Health Network that I have worked with, I seem to be the only one willing to work so far from home. In my HHHN career, I have worked at health centers and other facilities in Warrensburg, Chestertown, Bolton Landing, North Creek, Indian Lake, Long Lake, Speculator, and Wells. I must admit that there are many times when I wish I worked closer to home. Nonetheless, the work I have done both in the medical office and with my camera has been a very fulfilling experience. The appreciation that it has afforded me for the people and places in the Adirondacks is worth the time and effort it has

cost me over the past twenty years, and I wouldn't ex-
change those experiences for anything. These photo-
graphs and the stories behind them have taken on a
life of their own, and I have been encouraged to put
them in this book. Some readers describe it as a book
about Adirondack photography. Others describe it
as a book about the people of the Adirondacks. Oth-
ers consider it a book about rural medicine in the
Adirondacks. You may choose your own description.

In truth, my appreciation for the Adirondacks
began very early in life. I was born in Glens Falls at
the foothills of those magnificent mountains in the
very hospital I still make rounds in over a half-cen-
tury later. One of the early influences in my youth
was my maternal grandfather, Walter Livingston
Garrett. As a medical practitioner in the Adiron-
dacks, he had a substantial influence on the path I
chose in life.

The second of four generations of Glens Falls
dentists, my grandfather always seemed old to me
for as far back as I can remember. Indeed, he was al-
most seventy when I was born. Nonetheless, I found
him endlessly entertaining during my many child-
hood summers spent at his camp on Pilot Knob,
Lake George. There he would regale my cousins,
siblings, and I with spellbinding accounts of his
youth during the late nineteenth century. Born and
raised on Elm Street in Glens Falls, he earned a liv-
ing as a young man playing the violin at various ho-
tels and resorts on Lake George. He would travel up
and down the lake on the magnificent steamers
Minne-Ha-Ha, Horicon, and *Sagamore* like a Victo-
rian gypsy, eventually saving enough money to pay
his way through dental school in Baltimore. Upon
completing his education he joined his father's den-
tal practice, and in 1939 his son Richard joined him
as the third generation of Garrett dentists in Glens
Falls. (The fourth generation is represented by my
cousin Rick who practices in Glens Falls today, con-
tinuing a tradition that goes back to 1861!)

Long before my time, my grandfather dabbled

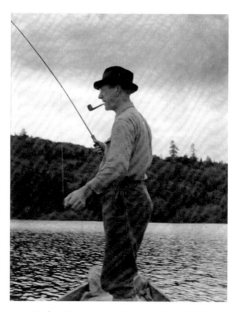

Walter Livingston Garrett circa 1940.

in photography with an old Kodak and played vio-
lin for the Glens Falls Operetta Club when he wasn't
drilling and filling teeth. He also enjoyed swimming
in Lake George, fishing, and participating in the
Glens Falls Historical Society. To me, he exempli-
fied the multifaceted Adirondack patriarch that he
indeed was. Listening to his stories over the cribbage
board on the front porch with the cool summer
breeze blowing from across the lake, I could see in
my mind's eye Glens Falls and Lake George along
with the people that lived there in those earlier
times. His colorful tales made me appreciate the his-
tory of Lake George and the great boats that sailed
on it. I also learned at a young age that there was
wisdom and character to be found in older people
and things from an earlier era, which should not be
overlooked. I can still recall exploits involving his
lifelong friends Bill McEwan, Roy Butler, his Uncle
Ray, and his father James Garrett, a lieutenant in the
Adirondack Regiment during the Civil War.

Having spent the best summers of my youth in
Glens Falls and on Lake George, I found it hard to
imagine living in the Adirondacks and *not* having an
appreciation for photography. Not only do the

mountains, lakes, forest, rivers, and people beckon the artist to capture their unspoiled images on film but they also dare you to compare your efforts to those of other artists who have gone before. The history of Adirondack photography is a rich one, beginning in earnest in the 1870s with the legendary efforts of Seneca Ray Stoddard. His magnificent visual (and written) chronicle of the scenery, architecture, people, and culture of the region has never been surpassed by any subsequent photographer. It is no exaggeration to say that the Adirondack Park, which now encompasses over 6 million acres within the Blue Line boundary, literally owes its existence to Stoddard. His historic lantern slide show presented to the New York State Assembly on February 25, 1892, helped to convince the legislature to pass the now-famous Adirondack Park Act. It would be only natural, therefore, for *any* modern-day photographer to use this great artist as a frame of reference. Although I am no exception, my affinity for Stoddard's work is as much historical as it is artistic.

My first exposure to the work of Stoddard was in the form of a 1964 pamphlet that recounted the history of the Lake George Steamboat Company. Stoddard's vivid images of the very ships my grandfather earned a living on opened a window into the past that allowed me to see the Adirondacks as they actually appeared over a century ago. Grandpa Garrett gave me further appreciation for vintage Adirondack photography by lending me boxes of old glass negatives taken when he was himself just a boy in the 1890s. As the ancient images of my grandfather's and great-grandparent's world appeared in the developer bath, I sometimes fantasized that I was the photographer and had just taken the pictures myself.

While attending college and later medical school at Pennsylvania State University however, my efforts at photography languished as I turned my attention toward the challenges of a career in medicine. During those years, my appreciation of Adirondack photography was kept alive by reading

Seneca Ray Stoddard self-portrait.

Adirondack Life magazine. The work of such photographers as Eliot Porter, Clyde Smith, Albert Gates, Gary Randorf, and Nancy Battaglia as well as the stories in that magazine made it an even easier decision to come home to Glens Falls. Sadly, my beloved grandfather Garrett died in 1972 at ninety-one, severing my link with the living past. It would be a while before I would appreciate how much I had lost.

In 1979, during the last year of my Family Medicine residency at Southside Hospital in Bay Shore, Long Island, I received a copy of *Seneca Ray Stoddard, Versatile Camera-Artist,* Maitland DeSormo's seminal biography of the nineteenth-century photographer. I didn't just read it, I devoured it. The book was truly an epiphany for me. I was enraptured by hundreds of magnificent Victorian images of lakes, rivers, mountains, and people. Reading about his life and career as photographer, writer, traveler, cartographer, speaker, publisher, artist, and environmentalist, I came to realize the extent to which he personifies the Adirondacks themselves. More amazing to me personally, I read for the first time on page 154 that by marriage, *Stoddard was my grandfather's uncle!* Not only did my Uncle Dick

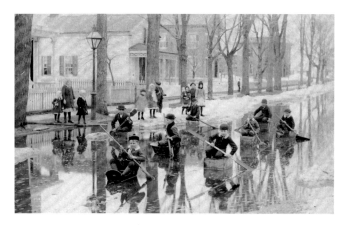

Stoddard's Elm Street scene, Glens Falls, 1887.

Garrett confirm this revelation but he also showed me a Stoddard photograph Grampa had given him that astonished me. It was a Glens Falls scene in 1887 where a number of children are paddling an armada of washtubs, basins, and other makeshift craft down flooded Elm Street on an early spring day while a small crowd of children and adults watch from the sidewalk. On the back of the picture, my grandfather had identified some of the children in the vessels as Stoddard's sons, while five-year-old Walter Livingston Garrett and his siblings Frank and Edith are among the bystanders! It had never dawned on me that the "Uncle Ray" my grandfather alluded to in his many tales over the cribbage board was none other than Seneca Ray Stoddard himself! I was racked with the cruel irony that, had I been born ten years earlier, I could have pumped my grandfather for enough information on Seneca Ray Stoddard to write my *own* biography of him! Now it was too late. Nonetheless, my deepening interest in Stoddard's work gave me the motivation to learn more about Adirondack photography.

In July 1980 I accepted a job working in the emergency room of Glens Falls Hospital, the very hospital where I had been born. For me it was the fulfillment of a lifelong dream when Harriet and I moved back to my hometown; I had truly come full circle. Because my wife was expecting our first child (our son Andy), I at first contented myself to collect old books, memorabilia, and sepia prints of Seneca Ray's works. I was even able to track down the last descendant of Seneca Ray's to have known him, his great-niece Ernestine Stoddard. Having missed a major opportunity to learn more about her great uncle from my grandfather, I was hoping she could recall some anecdotes. However, any hopes I had of gleaning any Stoddard memories disappeared when I met her. She was well into her 90s and was bitter and reticent over having sold his huge estate of photographs and other works for a pittance decades earlier. This fact, coupled with her failing memory, dashed my last hope of catching a personal glimpse of the man.

During this period, I discovered that there were other significant nineteenth-century photographers including Matthew Brady, William Bell, George Fiske, John Hillers, William Henry Jackson, Eadweard J. Muybridge, Timothy O'Sullivan, and Carleton Watkins. Their works were among the first to show the awesome beauty of the American west to the world, while the twentieth-century images of Edward Curtis, Ansel Adams, Eliot Porter, Galen Rowell, and Steve McCurry carried the genre to a new level. I also immersed myself in the books of such modern-day Adirondack lensmen as Nathan Farb, Bill Healy, Carr Clifton, David Muench, Gary

Randorf, Robert Glenn Ketchum, and, more recently, Carl Heilman II and Mark Bowie. In doing so, I came to appreciate improvements in the technical aspects of color photography, including medium- and large-format camera systems.

Despite all this research, I was nothing more than an armchair student of landscape art and photography until I was able to gain access to the Adirondacks on a regular basis. This was difficult to do with a newborn son at home and a job working twelve-hour shifts in the emergency room. My first great opportunity came in 1981, when I was offered a job by Dr. John Rugge, where I would be practicing family medicine for his fledgling Hudson Headwaters Health Network. My job called for me to work out of the various health centers, which gave me instant access to the entire southeastern Adirondacks. It didn't take me long to make up my mind. Soon I found myself driving into and out of the Adirondack Park every day, meeting real Adirondack people, and I knew I had found my life's work. I often had a little time to explore and, when conditions permitted, photograph my new surroundings during my commute. As time passed, my patients would tip me off about potential scenic views, and the occasional home visits that I was required to do in remote areas of Athol, Thurman, Stony Creek, Wevertown, Johnsburg, Minerva, Olmstedville, Bakers Mills, and other hamlets gave me still more opportunities to survey the area and its inhabitants.

All that was left was taking the pictures. I would bring my wife's Minolta SRT-201 with me to work, and so in the summer of 1981 I began my secondary career as amateur Adirondack photographer, initially focusing on landscapes. I had a couple of early successes, including a snowfall scene in Wevertown (see page 44). I quickly became dissatisfied with the limits of the 35mm format, however, especially when I enlarged my images beyond the standard 8" x 10" size; they seemed grainy and amateurish. I set my sights instead on the Bronica ETRS medium-format camera system, which offered a negative three times the size of the Minolta. The only problem was the price—over $1,300 in 1981 dollars for the modular camera with its film magazine, prism, lens, and speed grip. With an infant son and a house badly in need of basic furnishings, that purchase seemed like a pipe dream. It remained a dream for three years.

In 1984, I rediscovered my old baseball card collection that I had compulsively saved since my youth when, from 1960 to 1967, I saved my nickels and dimes to buy as many cards as I could. I had almost forgotten about them, keeping them for sentimental reasons undisturbed in an old cardboard box in the attic. Harriet suggested that I sell them and buy the Bronica. She still says that when she mentioned the idea to me, a lightbulb seemed to appear over my head. It was as though I had been saving those cards for some higher purpose, and that purpose was now clear to me. (Thanks, Harriet!) In September 1984, I bought a brand-new Bronica ETRS camera body, 75mm lens, AE-II prism, speed grip, and two film magazines. I also invested in a solid tripod, cable release, and polarizing filter. Once the Bronica was finally mine, I found that I was able for the first time to capture images very much as they appeared through my eyes with sharp definition that looked good even when enlarged to 20" x 24". The grain of the film ceased to be a limiting factor and allowed me to photograph scenes and objects that before would have been "lost in the translation" on 35mm film. It's amazing how little I have missed those baseball cards.

Because of my hectic lifestyle, most of my opportunities for taking pictures have come of necessity on my way to or from work. I commute to North Creek or Indian Lake almost daily and take every possible opportunity to use the morning or evening light to capture landscapes along the way. Many of my best landscapes were taken literally from the side of the roads that I commute on. Others were taken when I would have a little extra time during my commute to wander down a side road

and explore the area a little more. Several pictures were taken on my way to or from a home visit, where I might be called upon to drive along dirt roads so obscure and remote that I was in danger of becoming hopelessly lost.

As time went on, more and more of those images were actually taken *during* my home visits, when people I had met in my medical practice were kind enough to allow me to bring my camera into their homes. I have been able to compile a memorable portfolio of their portraits, which compliment the inspiring landscapes I see on my way to work every day.

During the process of taking the photographs found in this book, I made an unexpected discovery: when I was able to stop and take a successful picture, I noticed that the rest of the day went better, even if it was otherwise hectic and stressful. I found myself looking forward to going to work more. I also noticed that, when I made the effort to photograph a patient, it would seem to strengthen or enhance our relationship. Apparently, I had stumbled across a way to cope with a phenomenon commonly experienced by physicians called "compassion fatigue." According to an article in the April 2000 issue of *Family Practice Management,*

Compassion fatigue is a form of burnout that manifests itself as physical, emotional, and spiritual exhaustion. . . . Compassion fatigue is flourishing today, due in part to the demands of managed care. Physicians see more patients, do more paperwork, negotiate more contracts, and have less autonomy than ever before. Add to that self-imposed pressure to live up to their own high standards, and it's no wonder that many physicians feel like they're going up in flames. . . . In the past, the connection that many family physicians shared with their patients gave them the replenishment they needed to cope with the stressors of practicing medicine. But today, increasing demands have caused many physicians to stop taking the time to appreciate the love, respect, and appreciation that their patients want to share with them.

The authors are right; on many days I feel much the same as Robert Benchley must have when he said "anyone can do any amount of work, provided it isn't the work he is supposed to be doing at the moment!" And when my patients ask me how I cope with the stress of taking their lives in my hands every day, I would think about my camera and the photo opportunities I had in mind. In the last few years I have even begun displaying my patients' photographs on the walls of my examining rooms. It often makes for interesting conversations with the patients who I find waiting for me in those rooms and who frequently know those people in the pictures.

Aristotle may have been half-right; my job has certainly absorbed my mind, but it has not yet degraded it. In fact, I can hardly imagine a career that could have been more stimulating. This book represents a visual record accumulated over the first twenty years of my experience as an Adirondack physician. Perhaps it also represents my antidote to compassion fatigue. I suppose you could say I created it all in a day's work.

MY DAILY COMMUTE

Coolidge Avenue, Glens Falls.

I suppose it is fortunate that I enjoy driving a car. I'm not entirely sure why this is so; perhaps it's because I find the freedom and solitude a relaxing contrast to the hectic pace of the rest of my day. When time and conditions permit, I can also search for an image or two to capture on film along my way. It certainly doesn't hurt that my drive takes me past some of the most beautiful scenery in the northeastern United States, starting with the older residential streets of Glens Falls.

Just two blocks north of my home is Crandall Park, a jewel any city would be proud to include within its limits. Like many residents of Glens Falls, I have spent countless hours walking, running, biking, and cross-country skiing along the park's paths.

Within a few minutes I have left the city and find myself heading north on Interstate 87, otherwise known as the Adirondack Northway.

Less than ten miles north of home, the southern end of Lake George comes into view. Although it has lost some of its untamed beauty since Stoddard's day, Lake George still earns its nickname as "Queen of American Lakes." With its mountainous shoreline, hundreds of picturesque islands, and large tracts of undeveloped state land, the lake is a photographer's dream. Little wonder that I have spent so much time and film over the years trying to capture more of its visual treasures. Even when I'm too busy to stop, I can still savor a glimpse of the morning sun reflecting off the lake's majestic surface each day.

Crandall Park pond, Glens Falls.

Lake George from Sabbath Day Point.

Taking Exit 23 off the Northway, I continue north on U.S. Route 9, crossing the Schroon River as I enter Warrensburg. Driving through the quaint village, which has for over a century served as a gateway into the southeastern Adirondacks, I soon pass the Warrensburg Health Center, the hub medical center of the Hudson Headwaters Health Network. Although I now work in Warrensburg far less often than I do in the HHHN offices in North Creek and Indian Lake, I can still enjoy the view of the Schroon River that flows directly behind the health center.

When traffic is heavy, I may turn off Route 9 onto Elm Street where I pass the fire station, the library, and a number of stately old homes before bearing left at the town's bandstand where on summer evenings they have free concerts by local musicians. After I turn left onto the Hudson River Road, I will pass Mary Somerville's stately home on my left and then Ashe's Hotel before leaving town.

A little further north I pass Cronin's Golf Course before catching the first view of the Hudson River, which I follow for several scenic miles. Here the riverbed is broad and flat, which makes navigation by boat impossible when the water level is low. Nonetheless, this picturesque section of the river attracts fishermen, swimmers, picnickers, and artists, who try to do on canvas what I aspire to do on film.

The River Road crosses Millington Creek before running into Route 28, a highway that runs from Warrensburg all the way across the Adirondack Park before arriving in Utica. Over the years I have traveled its corridor thousands of times and have come to know many of the folks whose homes I pass along the way. Some have found themselves in front of my camera.

*Looking south on Hudson River Road
toward Ashe's Hotel, Warrensburg.*

Millington Creek, above Warrensburg.

Wildflowers along the Hudson below The Glen.

The further upriver I go, the smaller and wilder it becomes. To those whose concept of the Hudson River might be the mile-wide behemoth that rolls through the lower Hudson Valley, these headwaters seem a shallow trickle in comparison. But, to me, the Hudson River is an old friend that guides me along each morning as I go to work and each night as I head for home. Every day the view from my car reminds me why an entire school of art was created almost two centuries ago to celebrate and portray the river's beauty.

About ten miles north of Warrensburg is The Glen, where Route 28 crosses the Hudson and makes its way towards Wevertown. As I cross the bridge at The Glen in spring through fall, I often see kayakers who stay at the nearby Wildwaters Lodge fighting the currents below. In winter I'll guess at the thickness of the ice floes that form across the river. In spring 1980, when the frozen surface began breaking up after a very heavy rain, a downriver ice jam lifted the ice up to the level of the bridge itself, which normally clears the river's surface by over twenty feet!

At Wevertown I cross Mill Creek Bridge before encountering the last stoplight of my commute, even though I have two more towns ahead of me before I reach Indian Lake. That light marks the inter-

section of Routes 8 and 28. Here a left turn will take me toward the village of Johnsburg, while a right will lead east to Riparius on the Hudson River. Further along on Route 8 is Loon Lake and then Chestertown, where my wife works at the Chester Health Center. I always make sure to stop fully at that light, since many motorists have lost their lives there for failing to do so. I guess stoplights are so rare in the southeastern Adirondacks that locals don't quite know what they're for, and flatlanders

Wevertown farm, just north of
Routes 8 and 28 intersection.

Doris Fish pouring coffee at the White Pine Restaurant.

think that you just slow down as you go through them. As I continue on through Wevertown I pass first Knut Kristensen's unique, self-designed house and then Marty Waddell's log home on the right. A little further along is the White Pine Restaurant, where Doris Fish has been serving all-you-can-eat specials for as long as I have been working for HHHN. Soon I am passing the historic town of North Creek, where in 1901 Theodore Roosevelt first became aware that he was the nation's twenty-fifth president after learning that his predecessor William McKinley had died from an assassin's bullet.

If I choose to drive through town rather than around it, I must turn right off Route 28 and down into the business district. The center of town features many classic Adirondack-style storefronts such as the drug store, the local market, and Smith's Restaurant, which offers delicious homemade raspberry pie in season. Recent and welcome additions to Main Street include The Copperfield, a four-star hotel for the skiers that visit nearby Gore Mountain in winter, the white-water rafters in spring and sum-

mer, and the leaf-peepers in fall. At the other end of the business district is the even newer Tannery Pond Community Center, a magnificent state-of-the-art gallery, theater, and forum for all manner of community activities.

Once back on Route 28, the road again draws alongside the Hudson, following its western shore for mile after scenic mile until I reach North River.

Downtown North Creek.

*Windy morning on
Thirteenth Lake.*

Even smaller than North Creek, this tiny hamlet features Barton's Mines, the largest garnet mine in the world. They have been digging garnets out of the North River hills by the trainload for over a century, and the mine remains the largest year-round employer in the area. Just below where the road pulls away from the river and climbs towards Indian Lake, I can stop at Don Towne's 132-year-old store and buy a snack or a soda. Sometimes I'll turn left at his store onto Thirteenth Lake Road, which transects downtown North River on its way up to a small but beautiful lake. The morning sunlight streams across Thirteenth Lake in a magical way that draws me astray every now and then.

On my way back to Route 28 from Thirteenth Lake I can take a shortcut by turning left at the cemetery down Cleveland Road, named for Ben Cleveland's family. On the days that I take the usual direct route toward Indian Lake past Towne's Store,

I cross the border from Warren into Hamilton County where I encounter Black Mountain Hill, easily the most intimidating feature of the entire commute. Two of the deer I have hit on my commutes were while driving up that hill, including the one that almost came through my windshield. It was there also on a cold night in February 1993 where I spun out on black ice after coming down Black Mountain Hill, and only a guardrail prevented me from taking an unexpected plunge into the Hudson's icy waters. On each of these adventures I suffered major damage to both my vehicle and my pride.

Huge logging trucks struggle up and down the steep, three-mile hill, and moose apparently find it an inviting part of their migration route from central Vermont to the central and western Adirondacks. Regardless of the season, I always breathe a sigh of relief when I have put that stretch of highway

Rivulet above Black Mountain Hill.

behind me. Nonetheless, the view from my car only gets more and more breathtaking from that point on. By the time I reach the summit of the hill, I have reached an altitude of almost 2,000 feet above sea level.

Having reached the top of the hill, I am now in an area of the Adirondacks that seems far removed from what I left behind only a few miles back. I am much farther above sea level, and further west. As such, the weather can be very different, especially in winter when lake-effect snows off Lake Ontario reach the eastern edges of Hamilton County. I next find myself cruising along a long, flat, straight stretch of Route 28, which cuts across a large wetland known to the locals as Fagen's Flats. There, deer and moose can occasionally be seen browsing in the swampy fields, and at the northern end another hill brings me up to a spectacular view of the Snowy Mountain Range on my left, while Blue Mountain looms on my right. Both mountains tower thousands of feet above the surrounding countryside and command the view from every direction. Snowy Mountain's profile will be visible intermittently for much of the remaining drive. At 3,898 feet, Snowy's summit is barely more than 100 feet short of qualifying as one of the Adirondack High Peaks.

By now, a number of simple but well-maintained homes begin to appear along the way. Most seem to blend into the landscape, enhancing rather

After ice storm, below Fagen's Flats.

Hamilton County home along Route 28,
where turkeys are often seen.

than detracting from the natural surroundings. I have to watch out for a family of turkeys that frequent the area; I haven't hit one yet. Passing Tom LaVergne's home, I might glance over to see how large his woodpile has become.

Next, a short bridge takes me across beautiful Lake Abanakee, where exquisite scenery on either side of the road competes for my attention. Nestled in the Indian River Valley, the lake is often as calm as glass when I pass by around 8:15 A.M. Loons can often be seen gliding silently along its surface. Like its larger upstream neighbor, Indian Lake, this small lake owes its existence to a century-old dam that spills into the Indian River. Because the Indian River feeds directly into the larger Hudson a few miles downriver, the dams are now used to control the water level of both rivers during the whitewater-rafting season, just as they were once used to float logs to the pulp mills in Glens Falls. Thus, the town of Indian Lake can truthfully lay claim to being the "Whitewater Capital of the Adirondacks," which brings significant revenue and prestige to the local economy.

Over the next hill is the Hamlet of Indian Lake. Its eastern boundary is marked on my right by Byron Park, which surrounds the southern end of another man-made body of water named Adirondack Lake. Featuring yet another dam which towers above the roadway, the park includes picnic tables, a beach, a winterized log cabin for community activities, and a small dock that is at various times used by swimmers, boaters and floatplanes. Every Fourth of July, fireworks are launched from the park, and the town's residents can enjoy the sight of their exploding colors reflecting off the lake's surface. For most of the year, the lake also serves as the local airport for floatplanes that bring legions of campers, fishermen, kayakers and canoeists to the area.

Adirondack Lake is home to many of my patients who have built their retirement and seasonal dwellings along its southern edges. Despite its modest dimensions, they seem to find the lake's shores very much to their liking. Perhaps this is because of the lake's appealing scenery, notably the view from the northern shore, which features the Snowy Mountain range bracketed by evergreen-covered

Adirondack Lake dam from Byron Park.

islands. Those year-round residents who prefer an Adirondack winter to the tame warmth of the south are rewarded by the antics of the local deer population, which can often be seen frolicking on the lake's frozen surface as though it were their private playground.

It is an irony that, if you want to see the lake for which the town of Indian Lake is named, you must turn left onto State Route 30 past the fire station and drive about $3\frac{1}{2}$ miles to the even tinier hamlet of Sabael to get your first glimpse. At fourteen miles in length, Indian Lake is the fourth largest lake in the Adirondack Park and stretches for many miles along the road to Speculator and the southern end

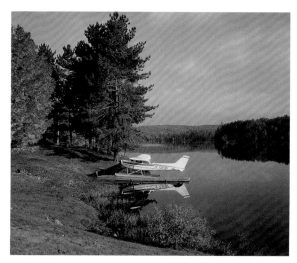

Floatplane dock in Byron Park on Adirondack Lake.

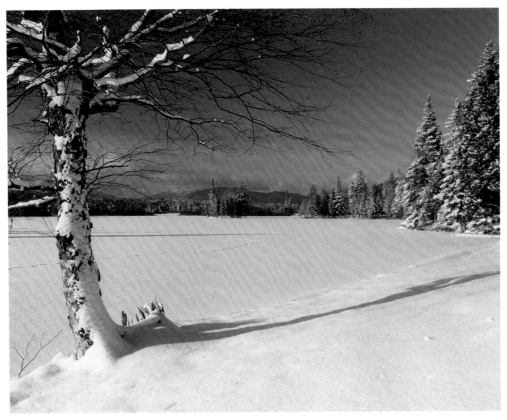

Looking toward Snowy Mountain Range from Adirondack Lake.

Deer on Adirondack Lake.

of the county. Although the town of Indian Lake is the largest in Hamilton County, it is so small that there is not a single traffic light to be seen. (Come to think of it, there isn't a stoplight in the entire county!)

Once, in May 1997 I encountered a large female moose as it sauntered through town, right out of the opening credits to the 1980s television series *Northern Exposure*. Black bears, foxes, snowshoe hares, turkeys, bobcats, mink, and even the rumor of a mountain lion are also considered part of the local population.

As I approach my usual destination of the Indian Lake Health Center, I pass by the Methodist

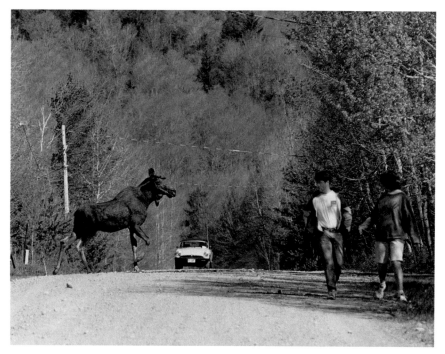

Moose on the loose in Sabael.

Church, the sporting goods store, the gas station, the only supermarket in Hamilton County, the chamber of commerce, two restaurants, the movie theater, the post office, the bank, the Catholic Church, the school, and the museum. If the town appears to be a movie set from the 1950s, then perhaps that is part of its appeal. Fortunately for me, the health center is among the most modern looking buildings in town, but even it has a certain rustic charm.

For a short while in the early 1990s, I worked occasionally at the Long Lake Health Center, which allowed me to drive another twenty-four miles deeper into the Adirondack Park. Despite the long drive, I appreciated the opportunity to experience even more breathtaking Adirondack landscapes, including Lake Durant and Blue Mountain Lake. It was the realization of a dream for me to be able to practice my profession in the geographic center of the Adirondack Park. Regardless of my destination,

though, by the time I arrive at work I often make at least one stop somewhere along the way to take a picture. Many times, my first patient of the day, having passed me en route to my office, will ask me during our visit whether or not I got a successful picture.

Of course, the drive home can often be more of a challenge, especially in the winter. There are almost no streetlights between Indian Lake and Warrensburg, and it is always pitch dark between October and March. Snow, freezing rain, or wandering wildlife can turn a relaxing fifty-minute cruise into a two-hour, white-knuckled ordeal. On the other hand, in late fall and early spring, I can often witness the last rays of twilight silhouetting Snowy Mountain as it casts its towering shadow across Lake Abanakee.

Occasionally, I will spend an afternoon visiting the group homes for the handicapped operated by the State of New York in Speculator and Wells, an-

Downtown Indian Lake.

other thirty-three miles down Route 30 from Indian Lake. On these days I return home along the section of State Route 8 that runs from Speculator to Bakers Mills, along the west branch of the Sacandaga River. One of the most remote and isolated stretches of highway I have ever traveled, this leg of my journey completes a 134-mile commute from Glens Falls. Yet, even after twenty years the promise of a new and unique look at the southeastern Adirondacks assures that I will again be ready to head north the next morning.

THE
DOCTOR-CAMERA-PATIENT
RELATIONSHIP

"Game in the Adirondacks" by Seneca Ray Stoddard.

One of the characteristics of Seneca Ray Stoddard's work that makes it so appealing today was his frequent inclusion of people in his work. Indeed, some of his most memorable images depict guides, lumbermen, vacationers, and other people actively involved in all sorts of activities, clad in the Victorian garb of the day. In the 1920s Alfred Stieglitz, during his summers on Lake George with Georgia O'Keeffe, produced some of the most provocative and unorthodox photographs ever to come from the area, including still-lifes, cloud formations, landscapes, and the human form. Yet, apart from Mathias Oppersdorff's excellent 1991 black-and-white book *Adirondack Faces,* most contemporary twentieth-century photography books

have depicted the Adirondacks as though they were utterly devoid of human habitation unless the people were standing on a mountain top or paddling a canoe. Although the Adirondack Park is indeed a sparsely populated area known mostly for its unsurpassed physical beauty, the people living within the Blue Line are as interesting and photogenic now as they were over a hundred years ago. The challenge in photographing them is in having the chance to know them well enough to capture a natural image on film. Even Oppersdorff, the professional photographer commissioned in 1986 by the Adirondack Museum to do a photographic book of the people of the Adirondacks, had a difficult time when he first started his year-long project. "At first I covered great

distances without much luck," he wrote in *Adiron-dack Faces*. " 'The hurrier I went' the less I saw. If I were to find the subjects I wanted, those who seemed to epitomize the Adirondacks in some way, I would have to spend time in a community and simply feel my way around."

My profession has given me the opportunity to "feel my way around" for the last twenty years, and I have gotten to know thousands of the most interesting people any physician or photographer could ever hope for. Even so, the idea of photographing people (other than my beautiful children) was a concept that was foreign to me when I first began using my Bronica in the early 1980s to photograph the Adirondack landscape. That changed in April 1987 when my boss, Dr. John Rugge, approached me about creating a photographic survey of our patient population. Since HHHN receives state and federal grants to fund health services for individuals who are uninsured, John wanted a visual record of the grants' beneficiaries in order to show government agencies how the funds were being used. I found this idea an intriguing challenge, since it would open up a different type of photography to me. As luck would have it, the perfect subject almost immediately appeared in the person of Ed Hebeart, whom I had been treating in Glens Falls Hospital for a severe stroke. I had just discharged him and had scheduled a home visit to ensure the adequacy of his living conditions, and so I brought my Bronica along. I had no flash or other artificial lighting equipment since I had little use for it with my landscape work. Instead, I used the natural light that was available in taking the picture. When I got my first look at the picture I had taken of Ed and his wife Golda in their trailer, I was pleasantly surprised with its powerful emotional impact. Four years after I took the picture, Mathias Oppersdorff would write what I felt at that moment: "The more I met and photographed people like these, the more I wanted to look for others like them."

I quickly realized that I was blessed with an abundance of amazing subjects, and I learned how to capture their images as I went along. I found myself particularly attracted to the older people, perhaps because of the great influence that my grandfather had had on me in my youth. I couldn't help but appreciate and wonder at the richness and variety of their life experiences and the way that Time had etched itself into their physical appearance. You could see those changes in the thinning or graying of hair, the tattoos on arms, the gnarling of hands, the lines in faces, or the look in the person's eyes. I also found that my older patients were often more willing to talk about themselves, or had less to lose by doing so.

My experiences as a physician have allowed me to share the entire range of human sentiment with my patients, ranging from the highest pinnacle of pride and hope, love and satisfaction to the blackest depths of grief and loss, despair and regret. Physicians who are reluctant or unwilling to do this are best advised to steer clear of rural primary care, where the local doctor may often be the only resource a person has to help deal with a situation that is beyond his or her ability to cope with alone. Yet even the most seasoned practitioner will occasionally encounter folks whose situations are so laden with the most extreme emotions in the spectrum that we are forced to confront the farthest limits of the human spirit and what it can endure. Over the years, I have been humbled by the enormous sense of trust that people have placed in me to maintain their health and help them deal with their problems. I have been able to recruit certain patients for my photographic work based on that trusting relationship, taking great care to preserve it along the way. The patients I chose must know and trust me enough to know I will portray them with honesty and respect, while I have to trust the patient to relax and be as natural as possible in front of my Bronica. By the time I have decided that an individual would make a good subject, I have usually concluded that they would be willing if not eager to let me photograph

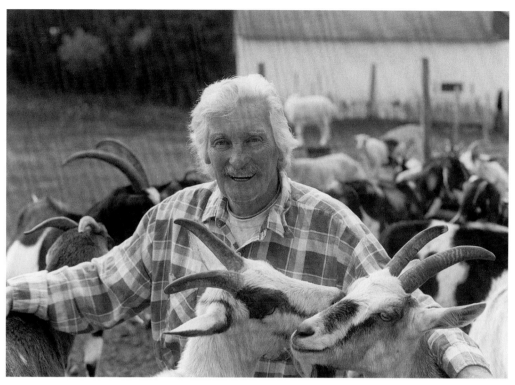

John O'Neill, Bakers Mills goat farmer.

them as well. Since I use no artificial lighting that would create a barrier or distraction between us and because I take time to socialize with my subject as I set up the camera, I can often create an atmosphere where the patient is paying very little attention to my camera when I trip the shutter. Consequently, I often come away with an image that is a realistic depiction of that individual in his or her environment. It is this symbiosis between my medical practice and my artistic pursuit that makes these images unique. The people you see in this book are not looking at a photographer but rather at their doctor. I feel that this crucial difference allows the true spirit and emotion of each person to shine through.

In many parts of the world, people are very uncomfortable when they find themselves in front of a camera. When Timothy O'Sullivan was attempting to photograph Shoshone, Apache, and Navajo Indi-

ans in the American West in the 1870s, he found even battle-hardened warriors afraid to sit in front of his camera. They called it a "shadow catcher," and they believed that their soul would not only be captured on film but also stolen from them in the process. When I look at the photographs of my patients, I believe that a small portion of their spirit *is* captured in the picture. Rather than robbing that spirit from them however, I feel that each view preserves or even immortalizes the essence of the individual in the picture. Perhaps this is another reason why the elderly are more comfortable letting me photograph and write about them; their approaching mortality makes them more willing to indulge in a form of "virtual" immortality.

When I look back at the many faces I have photographed, it vividly reminds me of the relentless-

ness of time's passing, which starkly contrasts with my landscape images. The timeless quality of the mountains, rivers, and forests only emphasizes even more the ephemeral and fragile nature of human life. Whereas the Adirondacks themselves have existed for eons, their inhabitants' lives are measured in mere decades. My images capture but a fleeting moment of each person's life, frozen in time. Often I would take an individual's picture or write a vignette, only to learn that the person had died soon afterwards. Some of the stories that accompany my earlier photographs were written years after the subject had passed away, while other patients have passed long after I wrote their narrative. Many people pictured in this book live on today. In any case, I have chosen to let their vignettes stay in the same time frame as when they were originally written, even if their lives have changed significantly after-

wards. After all, because my camera has frozen their images in time, it is only fair that their stories be kept similarly suspended. I like to think that, since the reader can still make eye contact with the people in this book, I have helped my patients cheat Time so they can all live on within these pages. These images are an attempt to portray a story or a feeling about the person. Some of the scenes may leave the viewer feeling wistful or sad, while others are uplifting or even amusing. If the observer senses an emotional bond with the person in the photograph and lingers to investigate the nooks and crannies around the subject, then I feel the picture has been a success.

I have had the honor and pleasure of knowing each one of the people in this book, sharing their problems and trying to help them live their lives. In doing so, they have given meaning and purpose to my life as well. I want them to be remembered.

PATIENT VIGNETTES

ED & GOLDA HEBEART

North Creek

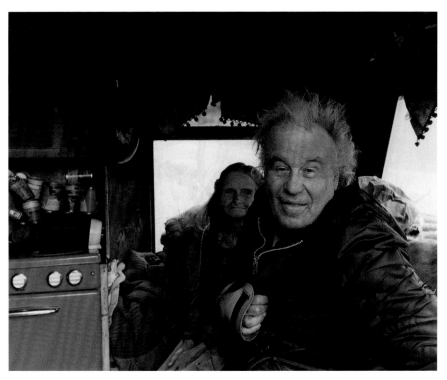

Ed and Golda Hebeart of North Creek, April 1987.

I came to know the Hebearts in the spring of 1987 when Ed had to be admitted to Glens Falls Hospital after suffering a devastating stroke. Although his speech was almost unintelligible and his right side was badly weakened, his only wish while in the hospital was that he could go back to his home as soon as possible. His homesickness was so intense that it was truly painful to witness. Even when he failed to regain much use of his right side and could not walk without the help of his tiny wife Golda, he refused any offer to relocate to a nursing home. There were also rumors from friends and neighbors that the Hebearts lived in unfit condi-

tions. When he was finally discharged to home, I promised to visit him to see what "home" was.

As it turned out he and Golda lived happily in a tiny trailer with no running water or electricity, heated by an ancient wood stove. When I arrived on a cold and rainy April day, I was dismayed to see how cramped and uncomfortable their living conditions were. Yet, I could also see the remarkable improvement in his mood brought about by his return home. I took this picture from outside the front door because there was not enough room for all three of us to fit in the trailer. He and Golda slept on a thin mattress, which rested on a slab of ply-

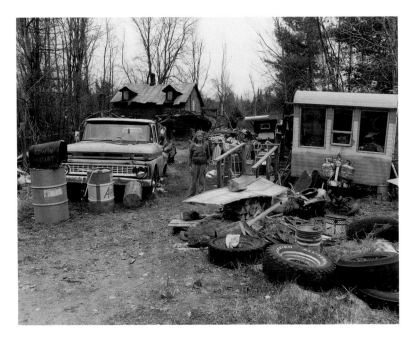

The Hebeart estate, April 1987.

wood, and a small lantern was their only source of light. They lived year-round in that uninsulated space, which could not have been more than fifty or sixty square feet in size. The look of peace and contentment is clearly seen in Ed's eyes and reflects the fact that he was perfectly satisfied where he was.

Although the Hebeart property was over a hundred acres in size and worth a large sum of money, they had no desire to part with any of it. It was well known by their neighbors however, that landscaping, housekeeping, and home repair were evidently not Ed or Golda's strong suit. According to Berniece Conlon, who once lived near their Bird Pond Road homestead, the Hebearts were *very* comfortable with their livestock. "They certainly weren't the only people in the area who had chickens and goats on their property, but I do believe they were the only ones whose animals lived *in their house!* In fact, the chickens and goats lived upstairs while Ed and Golda lived downstairs. I had a goat myself as a child, and whenever he would run away, I knew I could find him playing with Ed's goats, and he

would let me go upstairs and get him. The whole upstairs was full of chickens and goats!"

When after years of neglect the old house's roof eventually collapsed and the home became uninhabitable, Ed and Golda simply moved into the small trailer in the background. When *that* became uninhabitable, they moved into the yellow trailer in the foreground. Old vehicles served as closets when they could no longer provide transportation.

After Ed's health began to fail and he could no longer manage his own affairs, a court-appointed attorney was asked to straighten out Ed's finances and find him a safe place to live. Because Ed and Golda's only asset was their property, the land was sold to pay for back taxes and a comfortable home for the couple. They were relocated to a house that was relatively luxurious with central heat, running hot and cold water, and a modern kitchen. At Ed's insistence, the old yellow trailer was towed to the new property and parked in the backyard. Despite these seemingly humanitarian efforts, Ed was heartbroken when he lost his land. He died within a few months of the move.

FRANK "MOOSE" ANDERSON

Indian Lake Telephone Lineman

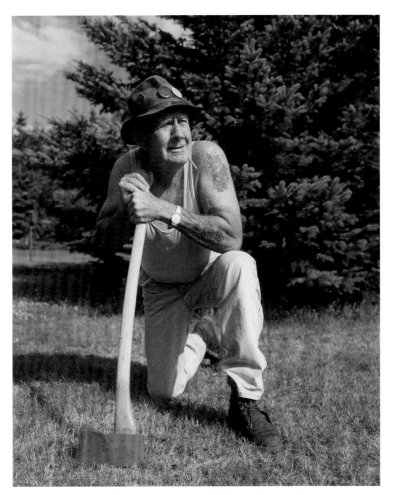

Frank "Moose" Anderson of Sabael, August 1997.

A former telephone lineman and Black Angus cattle farmer from Duanesburg, Moose and his wife Betty have lived on the outskirts of Indian Lake for over twenty years. He earned his nickname in the phone company by performing legendary feats of strength involving 400-pound telephone poles. Now long retired, he has maintained his Bunyanesque physique at the expense of countless trees that have felt the edge of his axe. Although Moose is nearly eighty years old, his handshake still leaves my hand feeling like a bag of bone meal whenever we meet. He likes nothing more

Guide boat on Lewey Lake, near Moose Anderson's home.

than to reduce a recently hewn tree to a tidy pile of firewood, unless it is to pull a pike up through the ice of Indian Lake on a cold winter's day. He can still be found doing his three-mile jog along Route 30 near the Snowy Mountain trailhead to this day.

When asked for his secret to preserving such a youthful mind and body, he answers without hesitation. "I don't take it for granted. Every day, before I go out for my run, I say a prayer thanking the Good Lord above for keeping me in good enough shape that I can still run up these hills." If his boundless energy could only be harnessed, we would never again need to burn fossil fuels. And woe to the stranger who addresses him as "Frank"! "Call me *Moose,*" he'll say, eagerly holding his big paw out to greet the unwary new acquaintance.

VERNA KNICKERBOCKER

Johnsburg Great-Grandmother

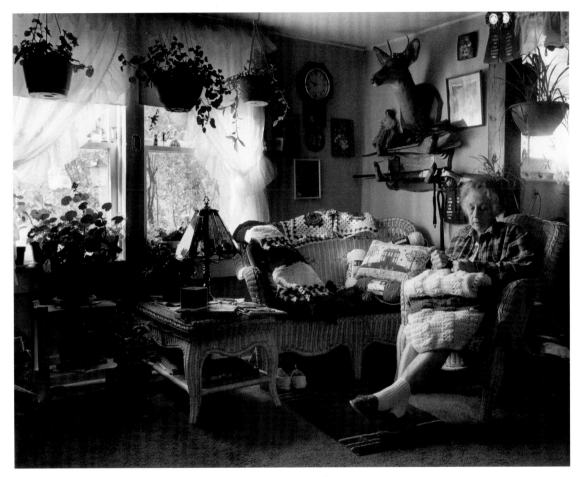

Verna Knickerbocker of Johnsburg, May 1998.

Verna Knickerbocker, the matriarch of her Johnsburg family, lives in a farmhouse near Crane Mountain that has been in the family for generations. After raising children of her own, she is now a great-grandmother who remains actively involved in the upbringing of all three generations that have followed her. Much of the history of her family can be seen on the walls of her home, which are almost entirely covered with a multimedia display of photographs, trophies, awards, weapons, and artwork. Her own creations can be seen around her, and she will spend hours at a time doing needlepoint or crocheting when she is not busy looking after various members of her extended family. Just

Mill Creek from Washer Hill Road, Johnsburg.

outside the home is a corral for the family horse, and all four generations of her family can often be found on the property at any given time.

When Verna described her farmhouse to me during a stay in Glens Falls Hospital, with its flower boxes in the front porch, I had the expectation that the best picture would be of her sitting on the porch. Indeed, on my arrival at the farm, I did photograph her there in her favorite rocker with her great-grandson at her feet. When we went inside to socialize a while longer, she picked up her knitting and started in on it while I began to realize that this was a better shot than the one I had already taken.

Here she sits in her favorite chair, from where she can watch the blue jays and robins frolicking on the feeder outside her window. By the time I took this picture, she had become so absorbed in her work and in regaling me with stories about her family that she had completely forgotten about my camera.

CHARLES CROTTY

Loon Lake Businessman

Charles Crotty checking his portfolio, August 2000.

If I am fortunate enough to live as long as Charles Crotty, I only hope I age as gracefully and slowly as he has in his eighty-nine years. Charles Crotty is living proof that aging is as much a state of mind as it is a quantity of time passed.

We met through his daughter Maureen Kelsey, a senior administrator for Hudson Headwaters Health Network. Although he looks like he has never been sick a day in his life, I soon learned that he has had his share of heart problems and arthritis like most octogenarians. What sets him apart is how little he allows these problems to slow him down. Unlike many older folks, he refuses to consider his infirmities an irreversible aging phenomenon. In-

stead of using a malady as an excuse to slow down, Mr. Crotty wants to know how soon it can be fixed so he can get back to his work as a businessman and bank director.

A third-generation native of Mechanicville, New York, he is very much aware of his family history. His grandfather Michael B. Crotty came to the United States from Limerick in the southwest of Ireland in 1865 to fight for the Union Army for $3 a day, only to find that the Civil War had ended just as he was arriving on the shores of his adopted country. Unfazed, he settled in Oneonta, New York, where he became a locomotive fireman for the Delaware & Hudson Railroad. It was in a D&H caboose on

Loon Lake.

September 23, 1883, that Michael Crotty and the legendary union advocate Eugene V. Debs created the Brotherhood of Railroad Trainmen, the powerful railroad union that still exists today. That caboose is now enshrined in an Oneonta park.

It would seem that Charles inherited much of his grandfather's self-confidence and drive. After graduating from Troy Business School in 1932 during the deepest depths of the Great Depression when unemployment was running at 40 percent, he landed his first job as a secretary in the Upper Hudson Rye Flour Mill in Troy for $12 a week. Within two years a financial crisis at the mill put him back on the street. Undaunted, he then started his own business, Charles Crotty Flour Feed & Grain, which lasted until his creditors went bankrupt. Between jobs he made a few dollars a week selling refrigerators and serving summons for the local district attorney. In 1936 he found another secretarial job working for the mayor of Mechanicville for a whopping $100 a month.

During the prohibition years, he was falsely accused of participating in a large whiskey distillery operation in Mechanicville out of the mayor's office and was indicted along with such colorful neighborhood characters as "Foxy" Cocozzo, his future brother-in-law. Charles's office had been wiretapped and he was heard to be supposedly passing checks to underworld figures, and the only way to clear his name was to find those cancelled checks to prove that they were actually legitimate expenses. Unfortunately, he was being tried in Utica, and the checks were in Mechanicville. Undeterred, the night before he was due to testify, he slipped out of house arrest and took a train to Albany. Apparently two Federal Treasury Department officers noticed his absence and closed in on him as he left Union Station. He hailed a taxicab and managed to elude the officers by sending the driver on a bewildering high-speed tour of the mill section of downtown Cohoes. Once in Mechanicville he was able to contact the deputy commissioner of accounts, an old school buddy who helped him find the checks that would exonerate him. Not content to dash directly back to Utica, Charles took a detour to visit his new bride and her family in Cohoes for a few hours, finally arriving by milk train back at the Utica courtroom as the judge was banging his gavel to start the day's proceedings. His lawyer, a native of Mechanicville who had successfully defended the notorious gangster "Dutch" Shultz, got him acquitted by the end of the day. Charles learned several valuable lessons from the trial. "Friends count, and every lead must be followed" he reflects in his memoirs. "In spite of the odds, never give up if you think you are right. And above all, THANK GOD!"

He used these hard-learned lessons during the rest of the Depression to support his growing family, even after losing his job in the mayor's office to the fickle winds of politics. He spent the remainder of the 1930s scratching together a living by serving summons, tending bar at his brother's restaurant, then running a parking concession at the Saratoga racetrack. As World War II approached, Charles found himself learning the heavy construction equipment business by doing secretarial work and then sales for Contractors Sales Company in Albany. During the war Charles held a second job at the Watervliet Arsenal, putting in 80-hour workweeks. As he looks back at his experience selling

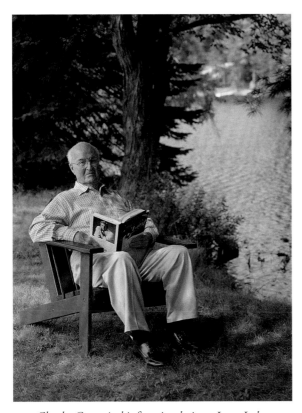

Charles Crotty in his favorite chair on Loon Lake.

construction supplies, he learned another lesson. "Sell yourself first, and then you will have the opportunity to sell what you represent. And stick with it."

When peace returned he went into business for himself in September 1947. Crotty's company, Capitol Equipment, Inc., sold quarrying machinery to mining companies such as National Lead in Tahawus and what is now Barton's Mines in North River. He secured his future and that of his company in the 1950s when the Interstate Highway System called for the construction of the Adirondack Northway. It was his machinery that crushed the stone and laid the foundation for Interstate 87 from Albany to Montreal. Capitol Equipment now has offices on the West Coast, which are overseen by his son Michael.

Crotty has not allowed the passage of time to leave him behind. In fact, he uses a computer every day to keep track of economic developments, and with the help of his grandson, he has created a multimedia CD-ROM autobiography. It includes not only the story of his life but also that of his ancestors going back to the Civil War, along with photographs and old songs. Its title, appropriately enough, is *It's A Wonderful Life—The Autobiography of Charles Crotty.*

Crotty's charm and youthful energy had already put him on my list of potential photographic subjects, but when my boss John Rugge asked me to photograph Charles for a surprise retirement present for Maureen, the project was lent some degree of urgency. With my hectic work schedule, I assumed that Mr. Crotty would simply accommodate my busy calendar in selecting a date for a photo shoot. I was wrong! I had to get in line behind his visiting grandchildren (he has thirteen, plus twenty-two great-grandchildren) as well as a crucial meeting of the board of directors of the Cohoes Savings Bank, of which he has been a member since 1963. I finally got an appointment between his bank meetings. "Last month we were trying to negotiate a merger with another bank," he told me as I photographed him sitting in his favorite Adirondack chair reading, appropriately, Tom Brokaw's *The Greatest Generation.* "Next month we have to fight off a hostile takeover. That'll keep you on your toes!" He didn't seem to mind a bit. I fact, I think he was looking forward to the coming conflict.

VINNIE CHARBONNEAU

North Creek Dude

Vinnie Charbonneau with nursing home fan club, October 2000.

We all know people who talk a lot yet say very little. People who display the opposite tendency are far less common, but Vinnie Charbonneau is one of them. Born with Down's Syndrome, Vinnie was never able to master speaking language skills very well despite having a fairly good grasp of language comprehension. Nevertheless, he has the uncanny ability to make himself understood with gestures, body language, and facial expressions in a way that would put Marcel Marceau to shame. And what Vinnie usually wishes to communicate to others is that he loves life and he loves people. "He's always had the knack for making

people understand what he wants to get across," says his doting mother, Nola Cyr, "even without speech or formal signing. He has a lot of patience, especially with people who don't understand him. Vinnie will keep trying until he gets the message through. He's not a quitter—he never has been."

It is fortunate that Vinnie isn't a quitter because he faces other health problems far more challenging than even Down's Syndrome. He was born with a very large VSD or ventricular septal defect, which is a hole in the wall or septum of his heart that separates the left and right ventricles. As an infant, he also suffered from congenital hepatitis, which made

Hudson River near Vinnie's home.

him so sick that he was not considered a candidate for surgical repair of his VSD. But though he only weighed fifteen pounds on his first birthday and showed significant delays in achieving the usual physical and intellectual milestones, he was still a cheerful and outgoing child. "He's always been very loving and friendly," recalls Nola. "As he grew he became very inquisitive and always wanted to be involved with other kids. His Dad, older brothers Lee and Nick, and sister Wynette were all very supportive and protective of Vinnie and were a great help in raising him. Everyone knew he was different, but they accepted him as he was."

When Vinnie was seven, Nola was told that his VSD would lead to a progressive deterioration of his heart so that he was not expected to live beyond the age of fourteen. The unoxygenated blood from his veins was mixing in his heart with the oxygenated blood from the lungs, putting increasing strain on his right ventricle and depriving vital oxygen to his brain and other organs. It was too late to repair surgically. "Vinnie's cardiologist told us that surgery could have been done when he was two years old, but Vinnie would only have had a fifty-fifty chance of surviving. We were never given that chance; the

doctors decided against it without telling us until five years later. But I have no regrets. He might not be here today if they had operated." To the doctors' amazement, Vinnie's lust for life was still going strong at age fourteen, about the time when I first met him. The specialists kept revising his life expectancy to sixteen, then eighteen. He is now twenty-eight years old. However, the VSD has taken its toll.

Vinnie's low oxygen levels have led to clubbing of his fingers, a blue tinge to his lips and extremities, and to a compensatory elevation in his red blood cell count so that over 60 percent of his blood is composed of the cells that carry oxygen instead of the normal 45 percent. He requires frequent phlebotomies to remove excess blood cells that thicken his blood to the consistency of syrup. This thickened blood has already caused a stroke that has weakened Vinnie further. It hasn't changed his personality though; he's as cheerful and affectionate as ever. He has been attending the day program at the Adirondack Tri-County Nursing Home in North Creek for several years, and he long ago charmed the staff as his picture plainly shows. "He's my pal," Nola says. "We've had some tough times, like when his father and I divorced, but we've muddled through them together. It's always been me and Vinnie." They share the same interest in music and culture. "Vinnie prefers music to TV. He loves the Beach Boys and his favorite car is a '57 Chevy." He also appreciates country music, the Everly Brothers, Jan and Dean, Elvis, and vintage T-Birds.

After Vinnie's stroke I asked Nola if she was prepared for the likelihood that she will outlive her son. "You never really are prepared," she admits. "I've been warned since he was real little that he wouldn't live very long. But I think he's done really well. We take one day at a time and we enjoy each day that we're together. I don't take one minute for granted, and I feel that has been a gift which most people never have." She paused, then added "but you're never really prepared."

JIM ORDWAY

North Creek Button Man

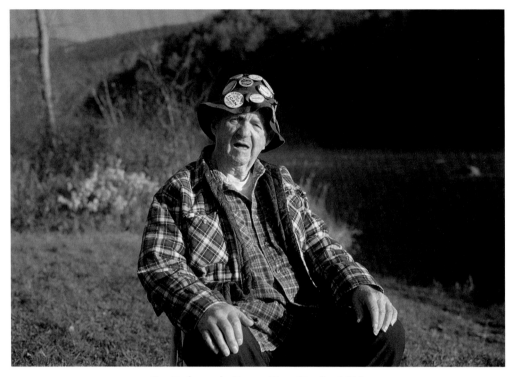

Jim Ordway, the Button Man, October 2000.

You'd never guess from looking at Jim Ordway, who has lived almost all his life within a stone's throw of the Hudson River, that he had any connection to the Kennedy dynasty (it's only a little one.) "The Kennedys used to race in the White Water Derby back in the early 60s," he once told me. The White Water Derby, as anyone who lives in the southeastern Adirondacks knows, is a rite of spring that has been attracting white water enthusiasts from all over the country every year since 1958 to the tiny hamlet of North River (just upriver from the village of North Creek). "I was helping out at the finish line down river at Riparius one year, and

whose canoe do I see stranded on the rocks but Bobby Kennedy's? I was able to help him get off the rocks and finish the race. He seemed like a real nice fella."

Rest assured, it was no coincidence that Jim happened to be there at that moment. In truth, he has been a regular presence at the Derby from the beginning, primarily as a vender of the official White Water Derby buttons. "Back in '58, I saw Elwin Monroe sellin' derby buttons for ten to twenty cents. He was sellin' 'em by the dozen, so I got some and started sellin' 'em for a quarter! I got pretty good at it, so I sold buttons for the Johnsburg Fish

North Creek Cemetery along Main Street as seen from Jim Ordway's home.

and Game Club too. Every year I would just walk up and down the river sellin' buttons. Everybody likes buttons." Over the years Jim sold many thousands of buttons in his spare time. Little wonder that to the locals Jim Ordway is "The Button Man," and he has a testimonial plaque from the Johnsburg Fish and Game Club to prove it.

When he wasn't selling buttons, Jim was raising a family and driving a delivery truck for A&B Oil Company, whose owner Kenneth Bennett was one of the founders of the Derby. "I drove that truck for thirty-seven years," Jim recalls. "I gave Vinnie Charbonneau his first truck ride when he was a little fella. I'll never forget the smile on his face." Now, many years later, Jim and Vinnie hang out together at the North Creek nursing home's day center.

One warm fall day before starting my office hours I picked Jim up at the day center, and we drove down to the Hudson at the site of the first White Water Derby finish line. "I sold a lot of but-

tons right here," he said as I set up my camera. We both enjoyed the bright October sun, fresh air, and familiar murmur of clean Adirondack water flowing by, so neither of us was inclined to hurry on such a pleasant day. Afterward, I drove him back to his home on North Creek's Main Street so he could show me his other passion—collecting bells. He has collected over two hundred of them in the past thirty years, and they cover his mantle, hearth, bookcases, shelves, walls, and doorframes. He has ship bells, church bells, train bells, school bells, cowbells, sleigh bells, ceremonial bells, and dinner bells. Some are made of brass; some are made of crystal. Others are made of iron, tin, copper, or ceramic. But his true calling is selling buttons.

I asked him as I took his picture whether he would be attending any future White Water Derbys. He looked at me as if I had lost my mind. "The Lord willin', if the Devil doesn't take me, I'll be there next year too!!"

KNUT KRISTENSEN

Stubborn Viking, Wevertown

Knut Kristensen of Wevertown, May 1999.

I'm glad that I got to know Knut Kristensen before his voice was silenced by Lou Gehrig's disease in 1989. Although the disease has gradually taken away his ability to talk, (as well as breathe, swallow, and move any muscles other than his eyes and right big toe), his thoughts can still be "heard" with help from a computer operated by a toe-operated mouse. And once you get to know him, you realize that he has *a lot* to say. I can still conjure his rich Norwegian accent when he tells me what it was like to find out he had amyotrophic lateral sclerosis (ALS) and what made him decide to fight it.

"I'm a stubborn Norwegian Viking that don't ever give up on anything," he wrote to me in an email that must have taken days to write. "I went through hell with ALS. Would I ever do it all over again? Hell, yes. You have to have goals to keep on going."

Born in Flekkefjord, Norway, in 1934, Knut recalls his earliest memories, still vivid and compelling. "I was playing on the sidewalk in front of the house. It was a bright sunny day. All of a sudden it sounded like thunder. I looked up and saw a whole mess of German planes flying over my head, on their way to bomb my country. The war had

Glen Creek, near Wevertown.

started." Growing up on a small farm that needed a lot of remodeling, he learned to love carpentry at a young age. "My grandmother wanted to pay for me to go to private college to be a doctor or a lawyer, but I didn't like books or reading. So the books stayed in the corner, and I kept on hammering nails." His ambition to survive and succeed was a driving force within him even then. "I had heard about all the money carpenters made in America, so I decided to take a trip across the ocean to find out if this was true. I arrived in New York City one day after my twentieth birthday and met Uncle Øle at the dock." Knut started a construction firm in New Jersey with two friends from Flekkefjord and built houses, apartments, and thruway plazas. By the 1980s he owned a forty-two-foot sport-fishing boat and was able to indulge in his favorite hobbies (fishing, hunting, skiing, and beer drinking) to his heart's content. Then it happened . . . "The ALS

started in my left arm, and from there my right arm, left leg, and then my right leg. . . . The very last time I went fishing, two guys had to help me get in and out of the boat, and every time I caught a fluke, one of the guys had to bring the fish into the boat. We caught a lot of fish that day, that was the main thing." When his symptoms began, his doctors were stumped. A neurologist at the University of Pennsylvania finally gave him the diagnosis.

They did tests that consisted of sticking needles into my muscles. I met the doctor later and was told that I had ALS and was given three or four years to live. I didn't like that old fart of a doctor and decided to go to another hospital. I went to Johns Hopkins, Columbia Presbyterian, and Mount Sinai Hospitals, but the old fart of a doctor from Philadelphia was right. I had ALS. So I sold my house in New Jersey and moved up to the north country. I guess because of the snow.

He bought a farmhouse in Wevertown and began building the dream house that he had designed himself. It was almost too late.

When I met Knut in 1989, he was already in a wheelchair, and could barely speak or swallow. I knew what was coming, and so did he. By the time I had to admit him to Glens Falls Hospital for respiratory failure from paralyzed breathing muscles, there was no doubt in my mind how Knut would deal with it. "I never liked hospitals, but if I didn't go when I did, I'd be dead now." He wasn't ready for that—not by a long shot. "You can't live with ALS without a feeding tube and a ventilator," so that is what he accepted. Having cheated death, he came home after a long hospitalization to learn how to live all over again. At first, things went better than hoped. His new house was finished and he had a devoted team of nurses and aids to help his wife and daughters Heidi and Kari take excellent care of him. He had just enough movement in one toe to use a special computer to read, write, and explore the Internet. As time passed though, things got tough. After years of support, Heidi took a promising job downstate. Soon after, his wife left him, taking most of their savings with her. Then Kari got married and started a life of her own. He still didn't give up. He still had goals.

One day, after years of loneliness with little prospect for real companionship, the improbable occurred (see the next portrait). You can almost imagine him sighing as he writes "Then I met Cate Mandigo. . . . Now I'm looking forward to a long and happy life with Cate and build that house we have the plans for if we ever get the money together. Those are my goals." I guess it *does* pay to have goals!

CATE MANDIGO

Wevertown Folk Artist

Cate Mandigo with Knut Kristensen, May 1999.

It's a little ironic to realize that Cate Mandigo, the popular and successful Adirondack folk artist, was inspired to embark on her present career while following a very different path in a very different kind of place.

A native of Corinth, New York, Cate didn't grow up planning a life in art. "I really couldn't paint when I was young," she recalls. "I had other ideas." Instead, she attended Georgetown University in Washington, D.C., where she majored in international affairs, which led to a ten-year career in international banking. As time passed, she began to have doubts about her career path. "It wasn't that I was unfulfilled by the banking job. Terrified was more like it...all that responsibility!" On a whim, she decided to take in the Grandma Moses exhibit at the Smithsonian Institute in 1979. The rest, as they say, is history. "It was one of those 'calling' sort of things," she says looking back. "Her art inspired me. I wondered if I could do that. I just had to try, so I bought $16 worth of painting supplies and started painting. I figured that after my fiftieth painting if I was still no good I would give it up. It worked out okay." Those of us who know her work would call that an understatement.

She decided to come home to Corinth to paint

Snowfall in Wevertown.

full time, while working in her father's flower shop. She set up her easel in his greenhouse and went to work. She also joined the Lower Adirondack Regional Arts Council and got some much-needed support. "They were a big help. LARAC is an outstanding organization. They are very good at helping new artists." Soon she was selling her art on consignment in galleries in Nantucket and Philadelphia, and today she makes a very comfortable living selling original works as well as prints, cards, and calendars. Along the way she has had time to raise her two daughters Kira and Mia. Today, she spends about five or six hours a day at her easel. "Painting is the thing I like to do best, except for being with my kids, and sometimes they paint with me. That is when I am happiest."

By 1997, all that was missing in Cate's life was companionship. That is the year she met Knut Kristensen. A less likely relationship can hardly be imagined.

We were introduced by a mutual friend. I had always been intrigued by his remarkable house, and I wondered who had designed it. When I heard that Knut himself had designed this house (which has the only geothermal energy system in the area) despite having ALS, I was even more curious. I was told that he had almost no visitors after his wife left him and that he could no longer speak without the assistance of a computer. He sounded like an interesting man, and I wanted to meet him. When my friend introduced us, I had made a script of topics to discuss, thinking that the meeting might be a little awkward. I quickly realized that this was unnecessary. After a while, I asked if I could come here to paint a couple of days per week. He said that I could, and so I would sit next to him and paint for hours at a time. He took an interest in my work and soon began offering suggestions. He would say why don't you do this or that, and the paintings would be so much better from his input. He knows so many things and has such an incredibly good eye for design. For example, he once corrected the way I had painted a sailing ship. Apparently, his grandfather had sailed tall ships from Norway to the South Seas trading spices. It was so much fun working with him. His close ties with previous generations back in Norway allowed him to keep family tradition and history alive, so hearing how it was when he grew up is like a review of U.S. history since colonial times. And yet when he came here to the U.S., he was able to jump right into the twentieth century. He's a very adaptable and fascinating person, and a lot of fun to be around. He would write me letters, even when it would take him hours.

They seemed to enrich each other's lives so much that she finally moved in to be with him full time, and he is now designing houses again.

On a recent visit, I took their picture as she was putting the finishing touches on her latest painting and he was writing his memoirs. The view of a forest-covered mountain filling the living room window was reminiscent of a Norwegian highland. The room's atmosphere was further enhanced by Cate's many paintings that adorned the walls. Knut wrote to me how he felt about his new companion. "I think Cate is the most wonderful person on this planet, and I love her very much. Could you ever, ever in your wildest dreams think that anyone could fall in love with me in my condition? I didn't think so, but Cate did."

ALICE DUNKLEY

Bakers Mills Publicist

Alice Dunkley of Bakers Mills, June 1999.

L ike everyone else, I have days when the stress and frustration of everyday life feel like a heavy weight pressing down on me. In those brief moments of self-pity, I may wonder why life treats me so harshly. But one of the most humbling aspects of my work is to see examples each day of how harsh life has been to others and how heroically they deal with their burdens. If I were asked to think of a patient who best exemplifies this heroism, it would be Alice Dunkley.

I first saw Alice in 1984 at the North Creek Health Center for an acute attack of bronchitis. Although I was struck by her earnest and sunny dispo-

sition, I was alarmed when I listened to her lungs with my stethoscope—I could hardly hear them. "How much do you smoke?" I asked. "About a half a pack a day for the past twenty years," she replied. That amount of smoking, as destructive as it was, usually does not cause such damage. I gave Alice the same blunt advice I give all smokers I see. "You better quit while you're ahead," I told her, "if you want to live to a ripe old age!"

The next time I saw Alice was five years later. Although she actually *had* quit smoking, her lungs were even worse. She was truly alarmed. A quick breathing test indicated advanced emphysema. She

Winter in the woods, Bakers Mills.

was only forty-two years old. A little alarm went off in my brain. Although I had never seen a case, I knew of a genetic disease called alpha-1-antitrypsin deficiency (A1AD) where, due to an inherited mutation, the blood protein A1A that normally protects the lungs from gradual destruction by our own immune system is not produced in adequate amounts by the liver. A1AD could explain her symptoms. I can still recall my astonishment when a simple blood test of Alice's A1A level came back almost undetectable—she had the disease. Fortunately for us both, four months earlier in November 1988 A1AD became a treatable disease for the first time in medical history. A company called Cutter Laboratories had just begun marketing the missing protein as Prolastin for the treatment of A1AD, which affects some 100,000 people in the United States, although less than 3,000 have been diagnosed. Fortunately again, her health insurance would be able to pay for the therapy, which even in 1989 would cost over $50,000 per year. When I told Alice that she had a rare genetic disease that was causing her emphysema and that we could probably stabilize her deteriorating lung function by starting her on weekly intravenous infusions of Prolastin for the indefinite future, you can imagine her reaction. "I was devastated," she recalls. "I was enrolled in college at the time. I was just starting a career after twenty years as a homemaker. I did not have time to be sick!"

Thus began an odyssey that has continued for over a decade up to this point. Alice has had to learn to administer the life-sustaining protein to herself through an implanted port under her skin and has had to infuse over five hundred doses so far. She has had to cope with dreadful costs of the treatment, frequent blood tests, and an eternal struggle with insurance companies for coverage of supplies and the

46

pharmaceutical company for a steady supply of the product. She has dealt with batches of Prolastin contaminated by mad cow disease, repeated disability physicals and pulmonary function tests, procurement of oxygen tanks and concentrators, recurrent attacks of viral bronchitis, trips to Boston for lung transplant reevaluation, all while trying to maintain some quality in her life.

If you didn't know Alice you might think that her burden would have long since broken her spirit. But Alice Dunkley is a very special person. Instead of allowing A1AD to incapacitate her, she has instead confronted her diagnosis in a way that adds purpose to her life by joining and promoting the National Alpha-1 Association. In this way she has helped others to avoid the suffering that she has had to endure. Despite having less than a third of normal lung function, she has mastered computer and networking skills and learned as much about the disease as possible. She has helped many other A1AD patients deal with all the medical, social, financial, and emotional stresses that follow the discovery of the diagnosis. Carrying her portable oxygen tank, oxygen conserver, oximeter, laptop computer, and A1AD brochures to state fairs, conventions, and meetings all over the country, Alice has screened over four hundred people for A1AD and identified six who have it, many at very early stages of lung dysfunction. She has also found fifty-six carriers of the gene. In 1997 she coauthored a manual for conducting A1AD screening entitled *You Can Do It!* She regularly counsels other A1AD patients by phone and e-mail for free, and she has organized support groups in Binghamton, Syracuse, and Albany. "I would like to see more people who are diagnosed have a place to go for support, information, and education," she explains. "For the first five years, I was alone with this. I don't want anyone else to have to go through that."

The casual observer who meets Alice might be forgiven for not grasping the full extent of her disability. After all, she has more mental energy than most people with intact lungs do. Once in a while someone who sees her parking in a handicapped space will question her, and she always has a ready reply: "I tell them I would love to trade my handicapped parking permit for their healthy lungs," she says. That usually shuts them up pretty fast!

WILLIAM & ANGELINA DEPPE

Johnsburg

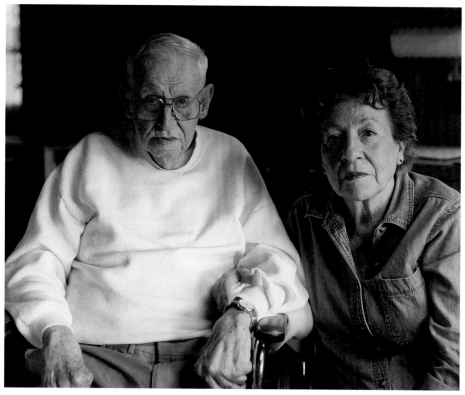

Bill and Angie Deppe of Johnsburg, May 2000.

The relationship between Bill and Angie Deppe is a modern day love story so poignantly romantic that it would seem corny if it wasn't real. Natives of Staten Island, they met in high school at the tender age of sixteen. Bill, in his distinctly Brooklyn/Staten Island accent, often told me of their first meeting as if it had happened a week ago. "The foist time I ever laid eyes on Angie I went head over heels! I went home and told my mother, 'Ma, I just met my wife!' She said, 'Ah get outta here and go ta bed!' It was love at foist sight!" Angie was a little skeptical; it took her two weeks to make up her mind. Their marriage was almost destined to end soon after it began, however. Bill was a charter member of Local #5 Boilermakers Union, and he did a great deal of work in the Brooklyn Navy Yard. Sometimes he did some rather hazardous work that included welding underwater while in a hard-helmet diving suit. One day, while in full gear, he fell overboard and began sinking under the weight of the heavy canvas and brass suit. "I had no air comin' in the hose, and I was drowning. I still remember praying to God as I sank, 'Lord, please don't take me now, or I'll never see

48

Mill Creek, Johnsburg.

Angie again!' About that time my friend Comer Thompson got a feelin' in his head like 'go check on Deppe.' He saw me sinkin' and pulled me out in the nick of time!"

While raising two sons, Alan and James, Bill began developing signs of rheumatoid arthritis at forty-two years of age. As the years went by, the disease took an increasing toll on his health to the point where he became totally disabled. Angie had to spend more and more of her time taking care of him, and when they moved to Johnsburg around 1980, care-giving became a full-time job for her. The disease not only crippled the joints in his hands, spine, knees, and hips, but it also damaged his central nervous system, leaving him with painful spasms and weakness in his legs as well as occasional seizures. He never lost his sense of humor, however, and was always scanning the newspapers for the latest medical breakthroughs, which he would clip out and bring to me when he came to the North Creek Health Center for his visits. No matter how much pain he was in, he always had a hilarious joke to tell my staff and I on his way home. He would often make fun of himself and his situation, and the biggest laugh I ever got out of him was when he

asked me how he was doing and I responded, "Well, I don't see any buzzards circling around your house yet!" He laughed so long and hard that I became concerned that it would cause a seizure. As Angie would wheel him out in his wheelchair, he would leave us with his famously enigmatic line "If you don't hear from me, let me know!"

In recent years, Bill's condition progressed even more, so that Angie had to help move and reposition him every fifteen minutes all night long, night after night, week after week and year after year. Her sleep was so badly disrupted that she became exhausted, yet she never complained or would consider nursing home care for Bill. For thirty-seven years she had become so preoccupied with his care that her own identity became fused with his. I took their picture one spring morning on one of my visits to their comfortable hilltop home, which overlooked a sweeping landscape of jagged mountains and undisturbed forests. I could see what it meant to Bill to be able to look out the big picture window at his beloved Adirondacks. He died only a few weeks after that visit, near their sixtieth wedding anniversary, having never spent a day in a nursing home.

Despite the release from constantly caring for Bill, Angie has had a tough time adjusting. "I'm goin' nuts by myself," she recently told me. "I've gone from one extreme to the other. I can't stop thinkin' about him for one second of every minute of every day. Even bein' around the kids and grandchildren doesn't stop it." I reassured her that it was common to experience the loss more keenly when two people were as close and dedicated to each other as they were and that it was the price the survivor had to pay for that closeness. "It was a lot of fun when he was alive," she assured me. "It's not so much fun now." I promised her that with time she would rediscover her own identity. But I must admit that I miss that stubborn German (as he often described himself) too. I haven't heard from him in awhile. I wish I could let him know.

GRACE GRAY

Stony Creek Widow

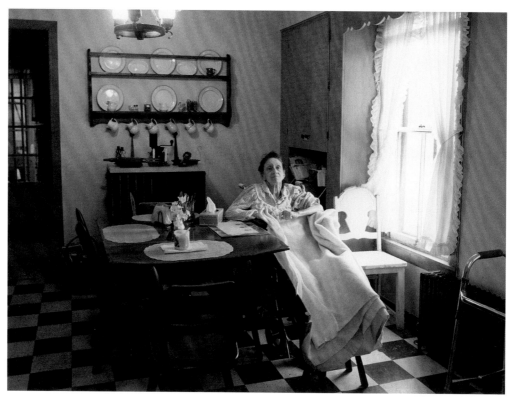

Grace Gray in her Stony Creek home, March 1992.

One of the most difficult things that can happen to an older woman is to lose her independence, especially when it forces her to give up her home. For many years Grace Gray, an elderly widow, was able to enjoy the solitude of her stately old Stony Creek house along the Hudson River. I met Grace at that point in her life when she had become too frail to live alone any longer. Fortunately, her daughter Joan had been able to move in and would bring Grace in for visits with me at the Warrensburg Health Center. For as long as she could,

Joan selflessly devoted herself to her mother's needs. As often happens, however, Grace fell at home one day and fractured her hip, requiring hospitalization and emergency surgery.

As time passed in the alien and bewildering hospital environment, Grace's efforts to recover waned as she began losing her will to get better. Her requests to go home were met with the accurate reply that she was too weak and wasn't ready. Unfortunately, she began refusing to eat and became malnourished and dehydrated. Joan's offers to take her

View of the Hudson taken en route to Grace Gray's home.

mother home for whatever time she had left were met with skepticism by the social workers responsible for her discharge planning.

Knowing Joan to be sincere and dedicated to her mother's recovery, I finally concluded that the only hope for Grace's survival was to send her home, weak and malnourished though she was. In her own environment she would be more motivated to eat and drink and get out of bed. With some trepidation I wrote the discharge order, promising to visit Grace in a few weeks and giving Joan a chance to restore her mother's will to live somewhat.

When the day came for me to visit Grace, late winter rains had washed out the ice on the Hudson and caused a flood that brought the water level up to within a few feet of County Route 3. Keeping one eye on the road and the other on the rising water level, I was relieved on arriving at her house along the river that cold March day to find Grace out of bed in her wheelchair, obviously feeling stronger and on the mend. Her appetite had returned, and she was responding well to home physical therapy. I took this picture while Joan made tea, and after an hour or so I left them feeling that I had chosen correctly in sending Grace home six weeks earlier.

Some time after this photograph was taken, I was accused by the New York State Medicare review board of a Level 2 citation regarding my decision to discharge Grace despite clear evidence in her chart of malnutrition and dehydration. In order to preserve my reputation, if not my license to practice in New York, I would have to defend my decision in writing. Choosing my words carefully, I explained my actions as best I could, and as an afterthought I attached this picture to my written reply. To my satisfaction, I received a glowingly exonerating response from the board a couple months later. "Physician response including picture generates great admiration for his dedicated care of this patient" was their assessment. The experience reminded me that a picture really *is* worth a thousand words.

THOMAS LaVERGNE

Indian Lake Woodcutter

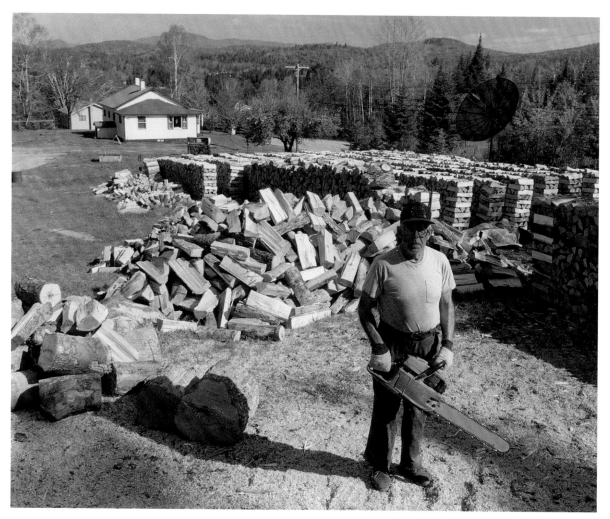

Tom LaVergne of Indian Lake, May 1999.

I have met many Adirondackers who enjoy cutting wood, including Frank Lillibridge of Thurman and "Moose" Anderson of Sabael. Of all the woodcutters I have known, Tom LaVergne ranks as the most impressive. Make no mistake, he doesn't cut wood because he *has* to, he cuts wood because he

likes to. "It's a hobby," he says casually, and he pursues it with a single-mindedness that only a serious hobbyist could appreciate.

Like the trees he so avidly cuts, Tom has deep roots. His grandfather came to the area from Quebec in the nineteenth century and purchased a large

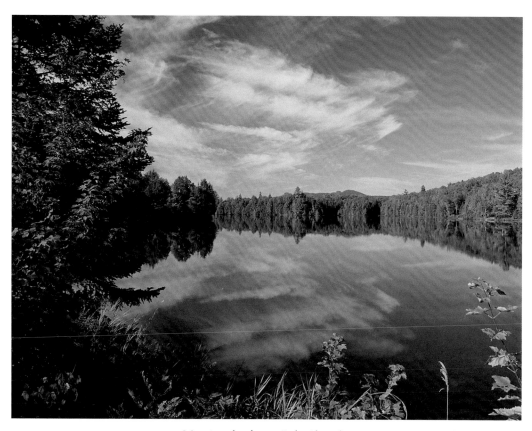

Morning clouds over Lake Abanakee.

tract of land overlooking Lake Abanakee. The location has suited the LaVergne family ever since. Tom lives just uphill from LaVergne Road and across the highway from his birthplace, seen in the distance.

Before becoming a full-time woodcutter, LaVergne worked construction and put in twenty years at Barton's Mines in North River, retiring in 1984. Even then, he cut wood in his spare time. Since retiring fifteen years ago, Tom has spent an average of six hours a day cutting, splitting, stacking, selling, and delivering wood all year round. LaVergne uses a Husquevarna chainsaw to cut huge logs into sixteen-inch sections. He then splits these into anywhere from four to eighteen "sticks" each. Eschewing the wood-splitter for the axe, sledge-

hammer, and maul, he produces 300 face cords a year. Expressed another way, that's 12,800 cubic feet of wood, enough to fill at least eleven tractor-trailers per year. That's *165* tractor-trailers *since* he retired!

During all the decades that he has been a one-man sawmill, Tom has never suffered a significant injury to his back or experienced anything worse than a bad cold. Although he credits his excellent health and exceptional physique to his "hobby," he doesn't like to brag about his accomplishments. Instead, he lets his hat do the talking. Whenever he heads out to his cutting field, he dons a sawdust-coated cap that says "Still Perfect after All These Years."

MERRILL INZERRA

Johnsburg Mother

Merrill Inzerra of Johnsburg, November 2000.

Merrill Inzerra can still remember a time when her life was like that of most other people. Like any devoted parent, Merrill centered her life on sixteen-year-old daughter Kristina, her only child. She even moved the family from their home in Johnsburg to Hilton Head, South Carolina, in September 1985 in order to give Krissi a wider view of the world before she started college. The last "normal" day of Merrill's life was on Thanksgiving Day 1986. "Krissi had just finished a book report and was looking forward to a trip back to Johnsburg for the holidays," Merrill recalled to me with a faraway look in her eyes. "She had gotten a part in the school Christmas show after several au-

ditions and had picked out a costume for it. She was teaching Christmas carols in French to the second grade students. She was really excited about things. The next day, she was gone." Krissi disappeared on November 29, 1986, and not a word has been heard from her since. "At first her father and I thought she was going to visit a friend. Her purse was next to her bed, her costumes hung on the closet door, and her finished book report was on her desk next to the un-cashed paycheck from her part-time job. When she didn't come back, we drove all around looking for her but couldn't find her anywhere. Then we got scared. You can't imagine what that feels like."

Merrill wanted me to tell her story in case it

might help find Krissi, but it was hard for her to re-live what happened next. When Merrill called the police, the local authorities seemed shockingly un-concerned. "First they made us wait twenty-four hours before they would do anything. Then they told us she would show up at school on Monday morning and not to worry." When Krissi failed to show up that Monday as predicted, the police didn't show up either. Merrill had to call them back, only to be warned to expect the worst. "They told me, 'You'll get your daughter back in one of four ways. Either she'll come back on her own, or knocked up, or beaten up by her pimp, or on a slab.' " A cursory investigation was shut down within two weeks after no leads or clues were found, and the South Car-olina State Police and FBI had no jurisdiction in the case, effectively taking away all legal recourse from Merrill. Instead of giving up, though, she tried to publicize her daughter's disappearance, hoping for a miracle. TV news networks throughout the south-eastern states broadcasted Krissi's story. Unfortu-nately, a false lead in 1989 was the only consequence of this effort when a satanic cult in Florida claimed to be holding Merrill's daughter hostage. Although this finally gave the FBI jurisdiction in Krissi's case, which led to the breakup of the cult and the arrest of its leader, the trail of her disappearance was stone cold by then.

Merrill received another false lead that claimed that Krissi had been seen with the DC Eagles, a Chicago-based motorcycle group. Merrill took a forty-eight-hour train ride from Savannah, Georgia, to Appleton, Wisconsin, when the Hilton Head Sheriff's Department refused to pay for the trip. After speaking to the motorcycle club members, she spent a week searching local homeless shelters trying to find a girl matching Krissi's description. Merrill actually tracked the girl down in a cocaine detoxifi-cation ward at St. Mary's Hospital, only to find that she was merely a look-alike. The disappointment was crushing. "The poor girl was homeless and ad-dicted to crack," Merrill told me. "She was so des-

perate that she tried to convince me that she was my daughter. 'I'm her,' she said. 'Please take me home.' " The experience left Merrill even more bitter. "Not only have I lost a child, I've lost faith in any system for finding her. There are so many missing children, but it's not a popular cause. No one seems to care. Two hundred children are reported missing every day. Why isn't there a national force dedicated to looking for those children? The bureaucracy doesn't care—no one wants to listen to parents' stories." Merrill spoke in front of the South Carolina State Legislature on behalf of the Victims Rights Coali-tion to protest the apathy she was confronted with during her search for Krissi. After her speech, she re-ceived a chilling reality-check by one of the state senators. " 'Children don't need rights,' he told me. 'They don't vote and they don't pay taxes. You might as well get used to that, little lady.' Children have no value to many people. Law authorities spend mil-lions on fighting drugs, but they don't seem to care about the kids who are taking the drugs."

As a way of coping with her grief and frustra-tion, Merrill started a group in South Carolina called Promise, which was dedicated to protecting children. She helped fingerprint, photograph, and collect dental records of almost 7,000 children in the state, then provided them with safety kits that helped them learn how to avoid abduction and kid-napping. She added a panel to the Memory Quilt, using a piece of fabric from one of Krissi's dresses, that hangs in the South Carolina State Capitol ro-tunda and honors the many missing children in the state. "You look for things to do," she explained. "It's hard to concentrate on my job. My daughter is up here," she says as she holds a hand above her head, "and everything else is down here," with the other hand extended straight down.

Merrill keeps Krissi alive in her heart for both their sakes. She was more than willing to let me photograph her in her home off South Johnsburg Road, surrounded by the things that still have meaning for her—Krissi's things. High school pic-

South Johnsburg Road, approaching Merrill's home.

tures help Merrill recall the happiest days of her life, now a distant memory. A picture of the Memory Quilt hangs behind her, while stuffed animals, a cheerleading trophy, and a clay swan made in kindergarten are priceless heirlooms to her. A diaper pin clasping a purple ribbon that commemorates missing children is her most treasured jewelry. The picture she holds has special meaning. "I was going through Krissi's belongings recently when I discovered an old Kodak Disc camera with the exposed film still inside. When I had the film developed, the last picture was this one taken of her. It was the first new image of her I'd seen in fifteen years. It keeps my hope going that she's still alive somewhere." But even that hope is a mixed blessing. "A mother is her child's protector, and I know that if Krissi is alive and has one lucid moment, she's thinking 'why doesn't my mother come and help me?'" That one thought prevents Merrill from giving in to self-destructive impulses. "I can still hear Krissi's voice and things she used to say. I believe if she came back and I was gone she would say, 'You couldn't wait one more day for me to come back? Didn't you know I'd come back if I could?' That's why I moved back to Johnsburg in 1995, so she'd know where to find me if she could."

The last two mementos in the picture also hold great meaning for Merrill. "The pillow was given to me by the people I work with at the insurance company. I don't know what I would do without them. They know what I'm going through and give me unbelievable support. Their hugs and their patience remind me that there are still a lot of good people in the world." Finally, there is the poem framed on the wall, which is the essence of her faith. It reads:

> Though distance may come
> Between a mother and child
> The bond that holds them close
> Will never weaken
> The love they share
> Will never be more
> Than a memory apart

Reciting the poem from memory, she adds, "I think that's true. I really believe it."

BOYD SMITH

Woodsman of Bakers Mills

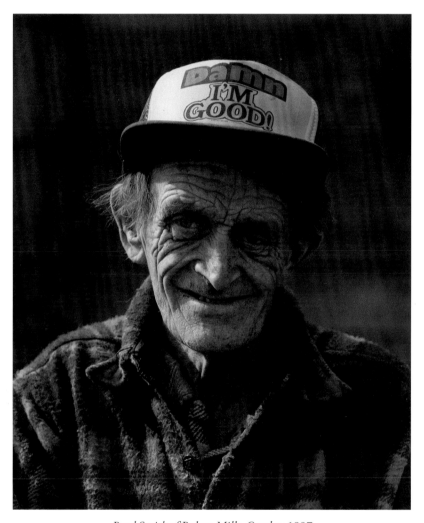

Boyd Smith of Bakers Mills, October 1987.

When I first came to practice in North Creek in the 1980s, there were still men to be found from a bygone era in the Adirondacks, when living off the land was a way of life and skills such as hunting, fishing, gardening, and carpentry made employment in a paying job seem irrelevant.

I was fortunate enough to know several of these latter-day pioneers, and it made me appreciate the ruggedness of the world they lived in from a new perspective. In terms of lifestyle and appearance, Boyd Smith was one of the best examples of a true Adirondack woodsman I have known.

For many years, Boyd lived at the end of a dirt road off Bartman Road on the outskirts of Bakers Mills with his wife Catherine. They didn't come out of the woods very often. Their simple home, lacking indoor plumbing, was heated with a small wood stove. Without any visible means of financial support, Boyd was able to provide the basic staples of life for him and Catherine with his knowledge, experience, and his two hands. In fact, a time traveler might easily have mistaken the Smiths' property for an eighteenth-century homestead, little different from that of the first settlers to inhabit the Adirondack forest.

Over the years, Boyd's character began to take on many of the qualities of his beloved Adirondacks—weather-beaten, craggy, rich in earth tones, not too tall but with an inner toughness and resilience. (He once endured a ruptured appendix for a week before seeking medical care.) Although his external appearance was known to frighten small children, what made an impression when you met him were his unassuming kindness, gentle voice, sparkling blue eyes and impish expression.

Since World War II when Boyd worked for the war effort in Schenectady, he had not been farther from home than brief trips to Glens Falls. A few years afterwards, I was astonished to learn that he and Catherine had moved to a trailer park in Florida. Apparently, they had belatedly decided to experience the conveniences of the twentieth century just in time for the beginning of the twenty-first!

FRANCES PAREY

Indian Lake

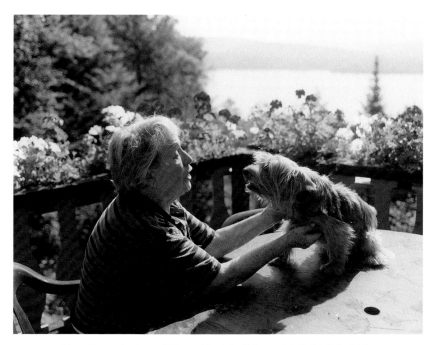

Fran Parey singing a "Happy Birthday" duet with Bubi, July 2002.

The bond between human and dog goes back over ten thousand years. According to the *World Book Encyclopedia,* Ulysses's dog Argus was the only creature to recognize him when he returned home disguised as a beggar after twenty years of adventures. Balto the Eskimo dog led a team that carried diphtheria serum 650 miles through an Alaskan blizzard in 1925. Laika, the space dog, was the first space traveler when the Soviets put her in orbit in 1957. Literature has Jack London's White Fang and Stephen King's Cujo. TV has Timmy and Lassie, Frasier and Eddie. Animation has Mickey and Pluto, Shaggy and Scooby Doo. Cinema has Arliss and Ole Yeller, Turner and Hooch. Not to be outdone, Indian Lake has Frances Parey and Bubi,

the singing dog. Although their paths intersected only a few years ago, the two were destined for each other.

Like many of her northern European counterparts, Frances, a native of Germany, was lured to the Adirondacks many years ago by the rugged landscape and extreme seasons, which recalled her childhood growing up in the Bavarian Alps. "Ever since I came to this country when I was twenty-one, I have always wanted a lake in front of me and mountains behind me, and I finally found it here." A successful restauranteur and realtor, she has spent a lifetime dealing with people all day. On her own time, she always had a soft spot for animals, especially Yorkshire Terriers.

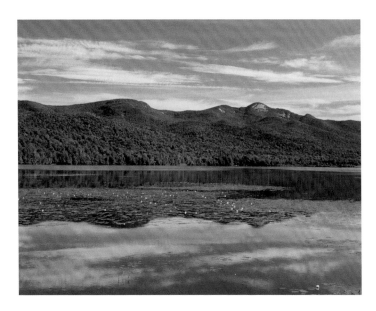

Snowy Mountain Range from Lewey Lake, near Parey's home.

My husband Carl and I had a Yorkie for nineteen years, and when he died we said "that's it, no more dogs!" But you know how it is when you are used to something. Pretty soon we were looking for another Yorkie, and my neighbor told me she had a friend in Vermont who was trying to get rid of hers. I called the woman and asked her why she wanted to sell him. "I can't stand him any longer!" she told me. I thought "that was a funny sales pitch," but I went to Vermont anyway and discovered why she couldn't stand him. She was a neat freak with a huge doll collection that covered all the furniture in her living room. He had decapitated several of the dolls, so he had to go. When I sat down, he immediately jumped in my lap. I think if he could have talked he would have said "take me with you, pleeeaassse!!!" I named him Bubi.

In response to my puzzled expression she explained. "No, 'Bubi' has nothing to do with boobs! In German it means 'little boy.'"

I asked her if he was a singer when she got him. "No," she said, "he taught himself to sing by watching TV. He liked the advertisements. At first he made a few 'yaps,' then he would yowl at certain ads, especially the Wal-Mart ads. He could be fast asleep,

but if he heard the Wal-Mart song he would run up to the TV, sit in front of it, and howl away until the advertisement was over." Fran talked to someone in Wal-Mart about Bubi's unique talent and was given a phone number to call. "She said to me, 'here's the number of the Big Boss—why don't you see if Wal-Mart can use him?' I immediately saw him as a big star, but then they changed the song and he didn't like it anymore. Now he likes the ad for Detrol, the incontinence drug—you know the one that says 'gotta go, gotta go, gotta go.' But his real talent is singing 'Happy Birthday.' Just say those two words and he's off."

One Saturday morning on my way home from a kayak trip on nearby Lewey Lake, I stopped by Fran and Carl's elegant home to meet Bubi. With Indian Lake as a fitting backdrop, Bubi and Fran did several takes of a rousing duet of 'Happy Birthday.' Groping for suitable words to describe the performance, I was speechless. Seeing my plight, Fran offered her own assessment. "I always say to him 'Ein Caruso bist Du nicht, doch trotzdem lieb' ich Dich,' which means, 'I love you so, but you're no Caruso.'"

DONALD TOWNE

Third Generation Grocer, North River

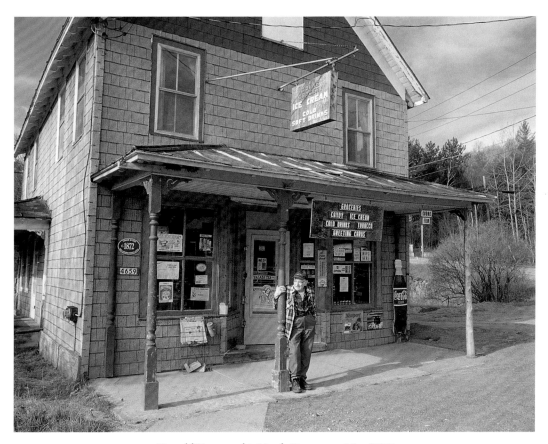

Donald Towne at his North River store, May 2000.

Can you imagine having a job that you enjoyed so much that you blissfully worked from 7:30 A.M. to 9:00 P.M. seven days a week for *fifty-one years* without even wanting a vacation for the last 30 of them? Meet Donald Towne, who says, "My vacation is right here." Don has been a one-man operation at his Towne Grocery Store in North River since June 1949 and is the third generation of Townes to do so. Located at the corner of State Route 28 and Thirteenth Lake Road, Don's store

has been owned and operated by a member of his family since 1872, when his grandfather Simon Towne erected it to serve the lumbermen and garnet miners working in the area.

Although his parents were natives of North River, they followed the lumber industry into Ontario, Canada, in the early years of the twentieth century, leaving the store in the keeping of Don's Aunt Ethel and Uncle James Hennessey. Don was born in Cochrane, Ontario, in 1920 and might well

The Hudson below Towne's store.

have remained a Canadian were it not for an apocalyptic fire that burned down his entire hometown when he was only fifteen months old. Rather than face the hardship of trying to provide for a family while relocating, his parents sent him back to his relatives in North River where he quickly bonded with the area. "When I wasn't helping with the store, I could go fishing or swimming in the river right across the road. I got to like it here pretty quick." Later on, he did go back to live with his parents who had relocated in Toronto, but his preference for locale was clear. "I didn't like Toronto at all," he recalls. "Too much concrete. I like the green grass beneath my feet and the woods, river, and mountains around me." When his Uncle Jim died in 1949, Don moved back to North River to help his aunt with the store. He's been there ever since!

I first met Don in the early 1980s when he would ride his ancient bicycle five miles to the North Creek Health Center for a routine checkup once or twice a year. Over the years, I couldn't help noticing that Don didn't change or age very much. One hot summer day en route to my other office in Indian Lake, I stopped into his store for a cold drink. As I walked in, I could feel the age of the place and suspected that it had also not changed much over the years. Don confirmed that the living quarters in the back and upstairs of the store were essentially unchanged since he moved in during the Truman administration. I wondered whether the store had some magic effect on slowing down time, and I asked Don what it was that made the store so fulfilling for him. With a voice so soft and low that it was nearly drowned out by the old electric fan hanging over the front door, he replied, "I never get bored. There's such a variety of things I have to do to keep the place running. I'm always busy, but I can sit down and relax whenever I want. There's no rush or pressure. I've learned how to pace myself, so I don't get riled easily."

Towne's Grocery is literally Donald Towne's whole life, especially since he does not own a car and lives in the store like those before him. And because he remains a bachelor with no children, the store has also become Donald Towne. Although realtors have made many offers for his property, he isn't interested in selling. I reminded him that he was now eighty years old and wondered what will happen when he is no longer there to keep the place running. "I don't feel old at all," he replied, turning the question aside. "Right now I'm gunnin' for ninety!"

MARY SOMERVILLE, GRACE STONE, & THELMA PLUMLEY

The Golden Girls of Warrensburg

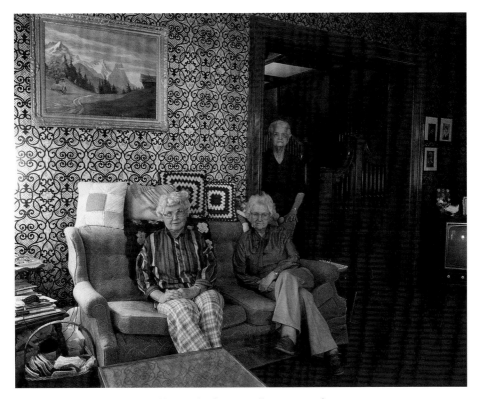

The Golden Girls of Warrensburg, September 1987.

These indomitable women came to know one another through their church and ultimately lived together in a stately mansion in Warrensburg, where they became fast friends. They supported each other and shared the rent, living much as the Golden Girls of TV fame. Mary was one of the most independent-minded women I have ever met, and her greatest passion was playing the organ at the Warrensburg Methodist Church every Sunday for many decades.

Once, after suffering a fall that landed her in the hospital for several days, she demanded that I discharge her in time for the Sunday service. When I protested that I was responsible for her welfare, she corrected me. "No sonny," she declared, "the Lord is responsible for my welfare, so you can just let me go!" Although she could barely walk, her fellow golden girls and the congregation made sure that she made the service, and she played flawlessly.

JESSE WARREN

Whitehall Farmer

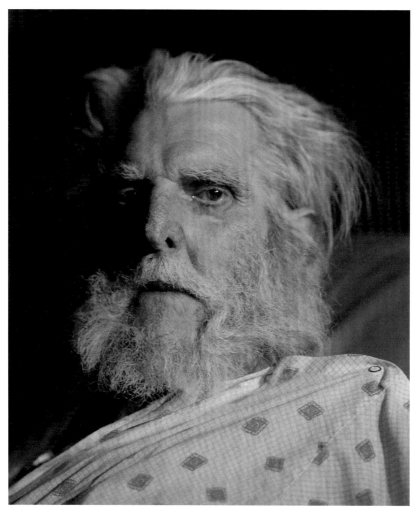

Jesse Warren of Whitehall, February 1998.

I only came to know Jesse very briefly while he was hospitalized at Glens Falls Hospital for treatment of advanced pulmonary emphysema. I was sitting at the nurses' station on 2-South when I saw him being wheeled by on his gurney, after being admitted by his physician Dr. Joseph Foote of Fort Ann. Struck by his piercing eyes and flowing white mane, I had the eerie sensation from the moment I first saw Mr. Warren that I was in the presence of John Brown, the abolitionist. Dr. Foote assured me

that Jesse was a much more passive and docile character than John Brown and was kind enough to introduce me to him.

I could easily see that Jesse was in very frail health, requiring oxygen whenever he moved around at all. Apparently, he had spent most of the last few months in the hospital, and his prognosis for recovery was poor. Yet he was interested in my interest in him and wistfully spoke to me about his long life as a farmer in Washington County as I studied his face in detail. I finally got up the nerve to ask him if I could take his picture right there in his room, and he seemed eager to cooperate with me. Needing some dramatic lighting to highlight his features, I frantically searched for some type of suitable illumination. Finally, a nurse recommended I borrow a gynecology exam light from the obstetrical floor. Running the entire length of the hospital and back for the lamp, I returned to his room breathless and sweating profusely. Trying not to appear totally crazed to this gentle stranger as I set up the lamp at his bedside, we continued our conversation while I pulled the shades in his room to darken the background. He graciously agreed to remove his nasal oxygen cannula for a minute or so, and I was able to make this image without causing him any discomfort.

It took several days to get the exposed film developed and have prints made for him. When I mailed them to his home address, they were returned as NOT DELIVERABLE. I then went back to the hospital to see if he was still there and learned that Jesse had died within two weeks of when this picture was taken.

MARGARET COLLINS CUNNINGHAM

North Creek Matriarch

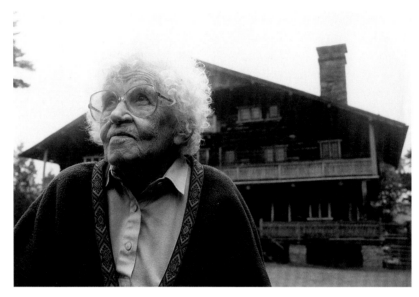

Margaret Collins Cunningham at Camp Sagamore, complete with black flies.

Imagine yourself a child in the early twentieth century, born and raised year-round in an Adirondack Great Camp that is owned by Alfred Vanderbilt. Imagine that your whole world consists of a private estate named Sagamore built on the shore of a beautiful lake and designed by the legendary William West Durant. This idyllic setting functions almost like a commune consisting of multiple families (including yours) whose purpose is to maintain and operate the vast complex of buildings and grounds for the Vanderbilt family. In winter you ride to school in a horse-drawn sleigh, and among your playmates are George and Alfred Vanderbilt II, whose father would soon perish in 1917 on the *HMS Lusitania* when it was torpedoed and sunk by a German U-Boat off the Irish coast. The nearest contact with the outside world is five miles over an unpaved road that leads to the tiny village of

Raquette Lake. There are no televisions, radios, or malls for recreation; instead, you hunt deer with your father and fish for lake trout from an Adirondack guideboat.

If you are fortunate enough to be Margaret Cunningham, you don't have to imagine this fantasy—you have lived it. And as you look back at the experience from a vantage point of seventy-five years later, you can think of only one word to describe it: "It was wonderful!" she told me in the summer of 2002.

One of five children and the only daughter of Margaret and Richard Collins, her family's roots were in North Creek and Chestertown, where the Collins family operated a farm. Richard's brother was the caretaker for Camp Uncas, the original Great Camp on Raquette Lake owned by J. P. Morgan, perhaps the wealthiest and most powerful man

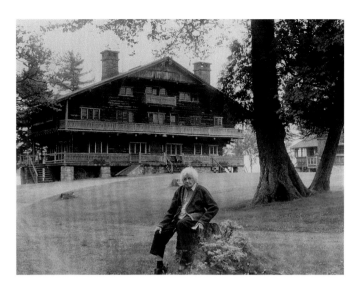

Margaret Collins Cunningham
at Camp Sagamore.

in the country. When Alfred Vanderbilt, Sr., bought nearby Sagamore Camp from William West Durant in approximately 1890, Morgan recommended Richard Collins as caretaker. Richard's daughter Margaret was born at Sagamore eighteen years later in 1908.

By her teens, thanks to her father's tutelage, the younger Margaret was already skilled at hunting, fishing, snowshoeing, and many other outdoor pastimes. "We were great pals," she recalled fondly of her time with her dad. "He really taught me to appreciate the Adirondacks. I can never repay him for that." She didn't spend all her time with her father though; she had plenty of playmates. Indeed, all the children of Sagamore grew up together. There were no barriers between the caretakers' children and the Vanderbilts' younger generation. "We spent many summer days together picking raspberries, blueberries, and blackberries," she reflects. "The Vanderbilts were wonderful people." Despite her bucolic childhood, she was, nevertheless, well educated. At seventeen she went off to college at St. Elizabeth College in New Jersey, where she majored in Latin. Did her taste of the metropolis whitewash her Adirondack upbringing? "No! It only convinced me that I wanted to go back!" Apparently, her first-

hand exposure to Adirondack history was only beginning.

After graduating in 1929, Margaret returned north to take a job teaching Latin, American history, and, later, medieval history at North Creek High School. Meanwhile, her father had saved up enough money to buy The Hedges, the Duryea estate on Blue Mountain Lake, which he converted into a magnificent rustic hotel in the tradition of Durant. To this day the Collins family remains a name to be reckoned with in Blue Mountain Lake, and The Hedges remains a breathtaking Adirondack destination.

In 1934 Margaret married Butler Cunningham, owner of the 1840-built North Creek General Store that had been owned and operated by the Cunningham family since 1906. As Margaret and Butler started a family, an event occurred to the north that changed the course of history in North Creek. The 1932 Winter Olympics in Lake Placid ignited a frenzy of interest in winter sports, and the Cunninghams became convinced that North Creek could become a skiing destination as well. They and a handful of families had the vision, amidst the depths of the Great Depression, to promote development of Gore Mountain and the North Creek Ski

Bowl. At first a trickle of skiers came. But by 1934 the trickle had became a torrent of people arriving by the trainload from Schuylerville to New York City, and Butler stocked his store with skiing supplies for the new winter tourism industry in North Creek. Today Butler and Margaret's son Pat owns and operates the Cunningham Ski Barn, while daughter Mary Cunningham Moro has helped save and restore the North Creek Railway Depot, where trains may once again bring skiers to town as they did during their heyday in the 1930s and early 1940s.

I am not the only person in town who looks upon Margaret Cunningham as the Matriarch of North Creek. At ninety-five she is still going strong, but as her physician I receive many anxious queries from concerned friends and neighbors. If Margaret gets a cold or a bump on the head, I will be asked "How is Margaret Cunningham doing?" or "Have you seen Margaret Cunningham lately?" by local townsfolk. It is always one of the pleasures of my job (or was before the new Health Insurance Portability and Accountability Act of 1996) to reassure the good people of North Creek that Margaret Cunningham is alive and well. This longevity is no coincidence, however. She has taken good care of the excellent genes she was blessed with, and her extended family remains devoted to her. Now living with daughter Mary, she maintains a routine of twice-a-day walking that began in the 1930s.

"I like to walk," she told me in 2002. "If you don't keep walking, you're done. I definitely believe that you can't stay healthy just . . . sitting in a rocker." I pointed out that her optimistic look on life was an asset too. "I have a positive attitude because those I grew up with did also." She then added, "I couldn't ask for a better family. You can usually rely on some action around here. If you miss the action, there is something wrong with you!"

Not wanting to miss out on any action myself and suspecting that Margaret might be intrigued, I proposed a trip back to Camp Sagamore early in June 2003, so that I could photograph her in a fitting environment while she had a chance to return to her birthplace. To my delight she accepted. I scheduled the visit on one of my rare Wednesday afternoons off hospital duty before the beginning of the summer tourism season, when the camp would be overrun with visitors. I called Jeff Flagg, the director of Camp Sagamore in April 2003, and he eagerly offered to meet Margaret, her daughter Mary, and myself at the Main Lodge on June 11, 2003. I prayed for good weather.

I didn't get it. As I burst out the door of Glens Falls Hospital that morning, I was met with a steady rain. Driving the seventy-five miles to Raquette Lake, I watched the rain slow to a fine mist. On my arrival, the mist let up and I was met with a dull gray sky but no rain. Pleased with myself, I opened the door of my Subaru to be immediately reminded why the camp was not yet overrun with tourists—it was overrun with black flies! Within seconds they were in my ears, my nostrils, my hair, my collar, and up my pant legs. When Margaret and Mary arrived, we quickly retreated to the dining lodge where Margaret produced a photo album of snapshots from her childhood at Sagamore. To Jeff it was a historical gold mine, and he made a very captive audience as we saw pictures of the Vanderbilts, her parents, and the staff. We heard about the orphaned fawn, which for a time was so tame it would follow Margaret's mother up the stairs of the staff quarters to sleep at the foot of her bed. Standing at the bottom of those stairs, I could almost see it happen as it did perhaps eighty-five years ago.

Finally we made our way outdoors once more, and Margaret stood bravely in front of my camera long enough for me to get the picture I wanted. Looking around the grounds, she forgot about the black flies and my Bronica for an instant and drank in the spirit of the place. My shutter opened as she looked up at what was once her bedroom window, and I think she was talking to herself when she said, almost whispering, "there's no place like home."

FRANK ROOT

Adirondack Woodsman

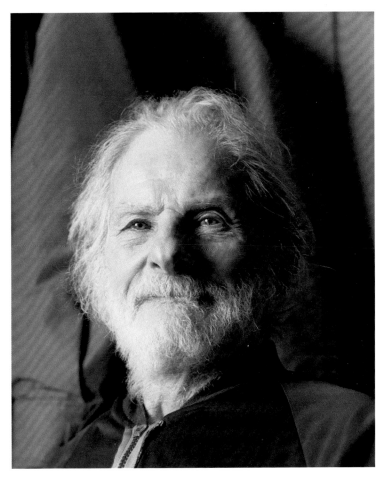

Frank Root of Warrensburg, January 1988.

Frank Root looked and sounded like a character actor from a 1947 western movie. The whiskers, the youthful twinkle in his sky-blue eyes, and his famously stubborn independence all bespoke a man who lived his life in the mountain forests as he pleased, and so he did.

Frank was born in the Catskills in 1904 and got his first job as a vegetable chef in Albany's Grand Union Hotel in the early 1920s. He began commuting up to the Adirondacks on his days off to stay in a two-wheeled trailer from which he honed his hunting and fishing skills. He enjoyed observing and tracking various "critters" and felt a special affinity for the black bear. "I know more about the black bear than *any* man!" he once announced proudly. "Y'know what a bear would rather eat than any-

Camp along the Hudson, in Frank Root's territory.

thing? Crisco! They love vegetable oil." He preferred vegetables to meat himself, as if Root was his title rather than his name. "I love roots and berries. I'd just as soon hunt ginseng as a deer." He explored a great deal of the Adirondacks on foot in his eighty-five years, from Crown Point to Thendara, from Malone to Saratoga. He seemed to savor the memory of every pond and forest he ever saw. One of his favorite stories was about the time he got lost in the woods near Paul Smith's for two days while tracking a bear. "I had no food, no matches. Man, I had nuthin' but my gun, and I couldn't eat that!"

In his last few months, his heart weakened badly and his wandering days unfortunately came to an end. He spent some time in Glens Falls Hospital, where he was adapting well when I took this picture. I wanted to photograph Frank partly because of his piercing blue eyes, and the free spirit that still shone through them. I also wanted to capture his image knowing that, like Boyd Smith, he represented a vanishing breed of Adirondacker, a man whose greatest ambition was to become a part of the Adirondacks themselves. In that goal he succeeded completely.

Before he died, his devoted nurses would listen as he recounted his adventures in the New York woods. My last memory of Frank was a conversation we had where he fantasized about going back to those forests one more time. He got a far-away look in his eyes and sighed, "Maaan, that'd be *beautiful!*"

70

DR. HUBERT CARROLL

Indian Lake Physician

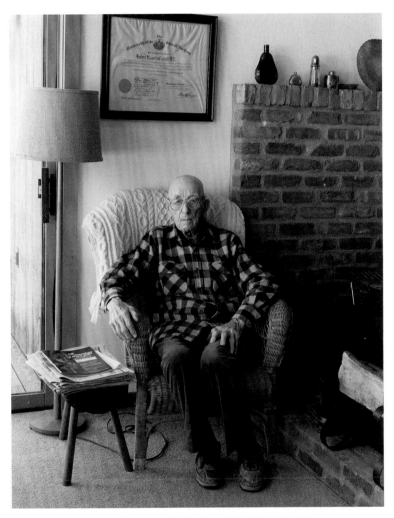

Dr. Hubert Carroll of Indian Lake, March 1998.

One of the unforeseen bonuses of joining the Hudson Headwaters Health Network in 1981 was the opportunity to know Hubert Carroll, M.D., a man whose medical career recapitulates much of the history of modern (and not-so-modern) medicine. Doctor Carroll was the town doctor in Indian Lake for almost forty years and was responsible for the creation of the present Indian Lake Health Center. An impressive bronze plaque commemorating his unparalleled contributions to the town hangs prominently in the waiting room to this day. His name figures prominently in the history of

New York's Hamilton County. In fact, there are over a dozen references to him in Ted Aber's 1964 *History of Hamilton County*. To me he remains the ultimate role model that I have to live up to every day.

Born in Indian Lake in 1894, he graduated from Indian Lake High School in 1912, and from Albany Medical College in 1918. Just missing service in World War I, he established his first medical practice in Endicott, New York. Within a year, he moved his practice to Raquette Lake while living in Blue Mountain Lake. Then, in 1921 the town board of Indian Lake authorized $1,200 to employ a town physician, and Dr. Carroll returned to Indian Lake. At that time his father was Indian Lake's undertaker (as well as its butcher) until he died in 1923. As Ted Aber pointed out, "In 1922 it was possible to have Dr. H. F. Carroll as final physician and his father William for disposal of the remains." From 1922 to 1925, Doctor Carroll served as Indian Lake's town supervisor, and he was also president of the town's Board of Education as far back as 1927. The present-day Indian Lake School was built in 1930 during his tenure. By 1928 his salary as town physician and health officer was a whopping $3,000!

During World War II, Dr. Carroll served in the U.S. Army Medical Corps, while his son served in the Signal Corps. Later on, he was instrumental in obtaining funding from Albany for the construction of the Indian Lake Health Center, which was built in 1959. The people of Indian Lake were so grateful to Dr. Carroll for all his work over the years that, upon his retirement in July 1959, they bought him a boat! It is in *his* health center in which I work today.

Dr. Carroll was still an active man when I first came to town in 1981. When he became my patient in the late 1980s, I found it a little intimidating to be caring for a pioneer of rural health care with his colorful history and vast experience. He could recall practicing medicine well before the discovery of penicillin, when a simple strep throat or ear infection could easily be fatal. "The first time I ever gave someone a shot of penicillin," he once told me, "it

Indian Lake, near Dr. Carroll's residence.

was to an eight-year-old boy in Sabael with pneumonia. I had no idea what would happen, so I stayed at his bedside all night. I didn't know if he was going to live or die. By the next morning, that boy's fever was gone, and he was breathing much better. It was a miracle." He told me that, during the Great Depression, he would often be paid with trout or venison when dollars were scarce. He thought nothing of driving an acutely ill patient down to Glens Falls Hospital in his Model T Ford, even when the round trip would take all day long.

When I asked whether he would allow me to photograph him, he agreed as a favor to a colleague, despite his modesty. As I was setting up my camera, we talked about the amazing advances in medicine, and his wife Jane served me homemade cherry pie. He impressed me with his directness and humility. I only hope that, when I retire from my practice, the people of Indian Lake think as much of me as they did of Dr. Carroll. I'd sure like to get a boat too!

ISABEL BROWN, BUNNY ANNABLE, MILDRED PROUTY, & HELEN DONAHUE

Four Merry Widows of Riparius

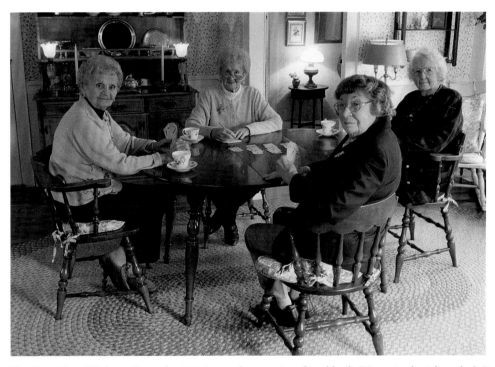

The Four Merry Widows, November 2001, a modern version of Stoddard's "Game in the Adirondacks."

Friendship is a powerful thing. Not only does it enhance the quality of our lives but it has also been proven to increase the quantity as well. The emotional and intellectual stimulation that goes along with socially interacting with other people has been scientifically proven to reduce the incidence of such common and deadly diseases as cancer, heart attack, and dementia. For many people the death of a spouse represents the beginning of the end of a happy and active lifestyle. Those people with the good fortune and aptitude to establish friendships can overcome the enormous stress that

widowhood can bring. Nowhere has this phenomenon been more vividly illustrated to me than the day I visited Isabel Brown's Riparius home during one of her bridge games.

Before my arrival I was aware that Isabel enjoyed partying with her friends, that she was eighty-seven years old and still driving her own car, living independently, and playing a mean game of cards. I also knew that she was the second youngest in the group of four women present. Bunny Annable, the scorekeeper in the game, was 89³/₄ when this picture was taken. She had recently been featured in the *Glens*

Single-lane bridge over the Hudson River at Riparius.

Falls Post-Star for being the oldest season-pass holder at the Gore Mountain Ski Center—she was taught how to ski by her first husband in 1934 two years before the first Olympics at Lake Placid! After a long and happy marriage she was a widow when, at the age of seventy-six, she met her second husband Henry Annable on the ski slopes of Switzerland. After their marriage Henry brought her to his home in Chestertown where she lives today, even after Henry's death in 1996. She still likes to ski. "Every morning I like to open Gore's triple chair at 8:30 if they say the snow is good. If I don't like the conditions at the top, I tell them to send a snowmobile to take me back down. That only happened once on 1999 and once in 2000. I have them well trained!" I smile. "Well, I don't want to break a bone!" she says sensibly.

Mildred Prouty of Johnsburg, the youngest at eighty-six, and Helen Donohue of North River, at ninety-and-a-half, rounded out the foursome. Apparently, ninety-three-year-old Esther Allison of North Creek would normally have been present, but on this particular day she was too busy to join the party!

I admit it was a little intimidating to be in the presence of four women whose cumulative lifespan of 353 years would stretch back to the year 1648. Yet, these were no doddering, passive old spinsters—they were vigorous, sharp-witted, competitive women whose conversation was charged with humor, challenge, and energy. Before I had even walked in Isabel's door, she turned her wit on me. As I lugged my camera bag and tripod into her vintage 1859 farmhouse, she stopped me with a quick gesture and, locking her eyes on mine said, "You're not going to be wanting any *nudies,* are you?" At that point I knew I was in over my head. As my shutter opened and closed repeatedly during their card play, I asked them how they were able to stay so young at heart.

"We're interested in *everything,*" Helen answered. "We enjoy playing bridge, going out, being together, reading books." "She reads *dirty* books!" interjects Bunny. "We live in very remote areas, but we can all still drive," offered Mildred. *"You're* pretty remote!" kidded Isabel. Then, "You should come to one of my cocktail parties, Doctor Way. I usually have one here every Sunday night. We usually have about twenty-five people over." "Except last sum-

mer," Helen corrected. "Remember the time you invited too many people? You decided to have *two* parties, one on Saturday night, and the other the next night!" "Once I had hurt a disc in my back," Isabel confessed. "I was supposed to have surgery on it, but I had a party to plan, so I cancelled my surgery and had a party instead!" "You never did have that surgery, did you?" asked Mildred.

As the banter continued, I could see for myself the powerful spiritual energy such interplay generated. I found myself wishing I could capture that energy and put it in a pill that I could then prescribe to my other patients. I had to admit that the medicine that kept these women young was not in any pill; it was their friendship. Bunny agreed.

"When Henry told me we would be moving from my home in Buffalo to his home in Chestertown, my Buffalo friends told me 'You're burning all your bridges!' I told them, 'I certainly *am!*'" "When Bunny moved here, she fit right in," Isabel added. "Some people can't do that." Bunny turned serious. "Henry had a lot of friends here," she said fondly. "Everyone liked him, so they accepted me whether they liked me or not." Casting a smile at Isabel she went on. "Isabel was nice enough to tell me after a couple of months that everyone would have liked me just because of Henry, but after awhile they loved me for myself. Now wasn't that nice of her?"

Yes, it was.

DONALD LAMB

Warrensburg Hermit

Donald Lamb of Warrensburg, October 1987.

The history of the Adirondacks would not be complete without mentioning its hermits. Some, like Noah John Rondeau and Adirondack French Louie, were celebrated individualists immortalized by photographers and admired by intellectuals. For every Noah John Rondeau, however, there are many other hermits whose status was forced upon them by the cruel circumstances of life. Donald Lamb was one of these.

As improbable as it would seem many years later, Don had been a tank gunner during World War II, fighting for his country from within the belly of a Sherman tank. During the course of many months of combat, Don's inner ears were shattered

Schroon River downstream from the Warrensburg Health Center.

by the roar from the 75-mm cannon which left him not only near-deaf but also with a maddening tinnitis that tormented him for the rest of his life. A simple and shy man by nature, few people ever knew what effect the war had on him. His hearing was so poor that he could not communicate with people, and it prevented him from being able to work or socialize in a normal fashion. In later years he became a hermit. During the rare occasions when he would stop for a hot meal at a local establishment in Warrensburg, he was sometimes subjected to ridicule from ignorant youth that were unaware of the reason for his aloofness and impoverished condition. This merely increased his withdrawal from society. Occasionally, he would visit me at the Warrensburg Health Center to see if there was anything that could be done to stop the terrible roaring in his ears. All I could do was clean the wax out of his ears and trade a few jokes with him. His tinnitis was so bad

from those tank battles of a generation ago that even hearing aids were useless to him.

Don lived for years on the southern outskirts of Warrensburg along Route 9 in a makeshift dwelling, which was easily visible from the Northway. Its unusual appearance attracted a lot of attention from passersby. He could often be seen riding an ancient, rusty bicycle back and forth from the town dump to his cabin. If one happened to notice, he was not taking things *to* the dump but rather removing materials *from* there! In fact, his residence was constructed largely from those items that he could carry across town, which accounts for the almost artistic, improvisational quality of its design. He was happy to have me record its existence for posterity. He proudly christened the place "Lamb's Shack," and it lasted about as long as he did. When he died around 1990, it took about fifteen minutes for a bulldozer to level the place. There is no trace of it today.

PEGGY PURDUE

Indian Lake Mountaineer

Peggy Purdue climbing Porter Mountain, September 2000.

One fine autumn day in the early 1990s an injured hiker from downstate hobbled into the Indian Lake Health Center for evaluation of an ankle sprain. He had apparently twisted it while climbing Blue Mountain, one of the Adirondacks' most beautiful peaks, which towers just eleven miles north of my office. Trying to give this sturdy young man the benefit of the doubt, I commented on how rocky and steep the trail is in places, and that was probably why he hurt himself. "It may be rocky and steep," he said ruefully, "but some white-haired lady three times my age blew past me like I was standing still. I think I twisted it just trying to keep her in view!" "Was she using a ski pole for a walking stick?" I asked. "Yeah! How did you know?" A knowing smile came across my face. "That would be Peggy

Indian Lake from Porter Mountain.

Purdue," I replied. "Don't feel bad—she leaves everyone in the dust!"

Peggy Purdue is a legend in and around the town of Indian Lake, where she and her husband Dick have been prominent citizens for decades. Dick held the offices of town supervisor and chairman of the Board of Supervisors of Hamilton County for many years, and Peggy was a regular participant in his town meetings to lend her support and opinion while raising six children. Blessed with a sharp intellect and possessing a sophisticated vision of how the Adirondack Park should be managed and preserved, Dick was always fiercely protective of the town and its constituents. As a result, he was never afraid to spark controversy and debate on their behalf.

Although Peggy's climbing exploits are now legendary, it's hard to imagine that, at age fifty, she was, as she put it, a 280-pound couch potato. "That's why I started climbing mountains," she recall. "I wanted to lose weight, and there were all these mountains around, so I started climbing Porter Mountain, Blue Mountain, and Snowy Mountain, then most of the high peaks and their rock slides as often as I could." After conquering these Adirondack peaks, she and Dick graduated to Mount Washington in New Hampshire, the tallest mountain in the northeastern United States at 6,288 feet. Within a year she had lost more than half her body weight, and the uplifting, energized feeling that was created within her re-inforced itself to the point where, as she freely

admits, the act of climbing became an obsession. Over the past twenty-three years, Peg estimates that she has climbed Blue Mountain over five hundred times, as well as at least three hundred ascents of Mount Washington. "I used to be able to climb Blue in thirty-seven minutes," she says matter-of-factly, "before I hurt my knee climbing Mount Washington in January 1994." Tearing cartilage as she was jumping over a boulder, she had to face the choice of continuing on another two miles to the summit or retracing her path down the very steep Lion Head Trail, which she had just ascended. Knowing that more climbers have died climbing Mount Washington than any other peak in the continental United States and facing arctic conditions, she couldn't afford to make the wrong choice. "Dick and I decided to go to the top. When we finally got there, I took off my crampons and had to limp and slide all the way down the mountain." She was only around sixty-six at the time.

When I recently pointed out to Peggy that her climbing, which had caused many injuries to her knees and ankles over the years, was an example of obsessive-compulsive behavior, she was at first defensive. I hastened to add that I was offering her a compliment and went on to explain that mild to moderate degrees of obsessive-compulsiveness, when channeled in a constructive fashion, could result in remarkable accomplishments. I admitted that, to a certain extent, my photography was another example of the same behavior. Perhaps that is why I had so much fun taking her picture climbing her beloved Porter Mountain. After all, I was photographing someone indulging in her obsession while I was indulging in my own!

Although arthritis has slowed her down somewhat at age seventy-three, Peggy is by no means idle. She and Dick have launched an Internet-based publishing company (www.superiorbooks.com) and have written a book entitled *Aging Defiantly* (as anyone who knows them might have guessed). In it, they express their philosophies on climbing, exercising, and the aging process:

To age defiantly is to overcome the prejudices and the conventional habits that can make aging a miserable experience and to adopt patterns of behavior that make aging a satisfying and rewarding challenge. Depending on your background and your genetic makeup, the process of aging may require a greater or lesser degree of defiance. To be on the safe side, a defiant attitude is the best place to start. . . . The optimum result for all of us is not to steadily go downhill until the last moment of our appointed time on earth but rather to dwell upon the loftier peaks of life until we tumble suddenly into the Valley. . . . The sooner we decide to get older according to our own plan, the more effectively we can raise our goals and defy the low expectations that society has defined for us.

In both word *and* deed, Peggy and Dick Purdue have literally written the book on how to grow old defiantly.

MARTIN WADDELL

Wevertown Highway Crew Foreman

Martin Waddell of Wevertown, September 1999.

When I recall my first encounter with Martin Waddell in 1983, it was his booming, baritone voice that most impressed me. He could take instant command of a room full of people just by saying, "Now, look here!" Over his fifty-year career, he put that voice to good use as a heavy equipment operator, highway construction foreman, and equipment superintendent. A loyal member of Local #106 Operating Engineers, Marty worked on projects ranging from the St. Lawrence Seaway to the New York State Thruway.

According to the 1885 *History of Warren County*, the Waddell family was one of the first to settle in the Johnsburg area in the 1790s, and they have maintained a presence there ever since. Marty was born in Wevertown on what his father said was "the coldest day of the winter" in January 1920. Like his ancestors, he was raised on the family farm that, in its heyday, occupied over 1,000 acres. Growing up among an extended family, he developed a great respect for his elders and ancestors. When his grandfather died in 1924, young Martin attended the burial in the Bates Cemetery off Route 8 in Johnsburg. At a young age, he took it upon himself to tend the family plot there, and years later he could still recall to me the reaction of his friends when they would encounter him in the cemetery. " 'How can you spend so much time among all

Waddell family gravesite, Bates Cemetery, Johnsburg.

those gravestones?' they would ask me. 'Because I expect one day to be buried here!' I'd say." As a fourteen-year-old, his first paying job was to serve as a caretaker for an elderly Wevertown bachelor who was dying. The experience left him with the sense that death was a natural part of life, not to be feared. That sense never left him.

For all the years that I knew Marty, he was always very much his own man. Although long ago he had a wife and son, they had parted company many years earlier. From then on, he preferred to live his life alone and on his own schedule. At sixty-three he came under my medical care for a mild heart condition. From the beginning he made it clear that he would tolerate my attention only as long as I did not get too carried away with "fancy tests" and referrals to "city doctors." He presented me with one of the first living wills I ever encountered, stating that he would not accept any life support measures if he should suffer a cardiac or respiratory arrest. It took me more than two years to convince him to accept a simple blood thinner for his irregular heartbeat, and only when he finally understood that it would protect him from suffering a debilitating stroke. On my morning commute to work, I would often find myself following behind his red Ford pickup for mile

after tedious mile heading north on Route 28 as he meandered along at 40 mph. Many times he was on his way to my office for a blood test or an office visit. Fretting over all the work I could be getting done, I found it hard to contain my frustration when we would finally pull into the North Creek Health Center parking lot together. Nevertheless, I could only smile in spite of myself when he'd open his window and bellow out to me as I hurried into my workplace: "Doctor Way, once again it appears that you are late for work! Maybe you should get up a little earlier!" When some of those blood tests began to show a mild but suspicious form of anemia, he refused any workup beyond the few studies I had done in my office. "I'm not goin' any farther south than here!" he would insist over my protests.

Nonetheless, Marty continued to enjoy good health until fall 1999, well into his seventy-ninth year. It was then that he began to feel weak and short of breath when he would climb the small hill from his garden back to his cabin in the woods. After consenting to more blood tests at my office, it was apparent that his anemia was now so severe that less than half the red blood cells of a few months earlier remained. When I explained with some alarm that it would be necessary to arrange a transfusion at once

to stabilize his life-threatening condition, he refused without hesitation. "There's two things in this world that I dislike the most, and they're both transfusions! I'm content to let Nature have its way with me." No amount of cajoling or reasoning would sway him. I asked Marty whether his decision was based on a religious belief in eternal life. He laughed. "No, I believe that you're born, you live, and you die. Death is natural; it happens to everybody. I expect that after I die, John Alexander (the undertaker) will bury me next to the rest of my family. He'd better, or I'll haunt him for the rest of his days! I've had my headstone carved and in the graveyard since 1962, right next to my parents and grandparents. I'm as ready as I'll ever be."

It was hard for me to accept his decision, knowing I could have extended the quantity and probably quality of the time he had left. I was impressed, though, with the conviction of his decision and realized that the anguish I was feeling was *my* problem, not Marty's. There were no family members to give him reason to change his mind, and he counted on me to honor his decision. "You've been a good friend to me over the last sixteen years, and I appreciate you for accepting me for what I am, just a plain country boy who doesn't want to live too long." I had never before encountered a person with such serenity in the face of an expected yet avoidable death. It occurred to me that the way he had lived his entire life had prepared him for this moment. His bond with family members had largely come through years of tending their resting places at the cemetery a few miles from his house. His desire to join them there was now stronger than any relationship he had with the living.

He invited me to his comfortable log cabin for one more visit on September 27, 1999, and was more than happy to let me photograph him. As he posed on his porch for my camera that warm autumn afternoon, I casually mentioned that I would take a vertical shot of him first. "I'm about as vertical as I'm likely to be!" he quipped with gallows humor. It felt strange to look through my viewfinder at a still robust man in full control of his faculties who we both knew would die very soon. Yet, despite my affection for him, I knew it was what he wanted and I knew why. Instead of arguing, we passed the time just talking. I knew him a lot better by the time I left. Although I promised to come back the next week, I suspected we might never meet again.

On the morning of October 6, 1999, Marty stood up with the help of his good friend Gareth Griffen, only to slump to the floor unconscious. He died peacefully a few minutes later, less than nine days after I took his picture. Soon after, John Alexander laid him to rest among his beloved family in the Waddell plot at the Bates Cemetery. "He told me he didn't want to be laid on his back like other people," Alexander says. "He instructed me to put him on his side with his head on a pillow the way he laid when sleeping. Marty wanted to be as comfortable as possible in his grave. He was somethin' else!" Despite Marty's stern wish to forego a funeral service, John said a few words over the grave with some friends and distant relatives present. John is now hoping that Marty doesn't haunt him for it.

BENJAMIN FRANKLIN CLEVELAND

North River Centenarian

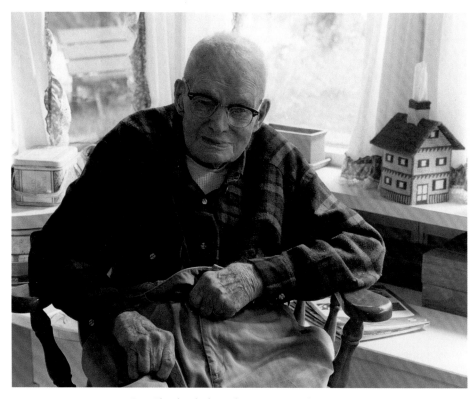

Ben Cleveland of North River, September 2000.

One of the reasons I enjoy caring for the elderly is that I get to know people like Ben Cleveland. Although Ben was only in his late eighties when I first met him, he was almost 104 years old by the time I took this picture. His daughter Genevieve Davis had been encouraging me to add his image to my portfolio for some time, and I was finally able to stop by on a mid-August afternoon. As I was framing him in my camera's viewfinder, It struck me that I was photographing a man whose life has spanned three different centuries!

It's hard to appreciate how old Ben Cleveland is.

One of ten children, Ben was born before the age of automobiles, and had already celebrated his seventh birthday when the Wright Brothers flew the first airplane in December 1903. President Grover Cleveland, who happened to be Ben's eleventh cousin, was serving his second term in the White House when Ben was born. When he was in his late twenties, he paid $600 for his first car, which was a Model T Ford! It wasn't until he was fifty-three years old that he lived in a house with electricity. He can recall the presidency of Theodore Roosevelt. He is the oldest living World War I veteran in Warren

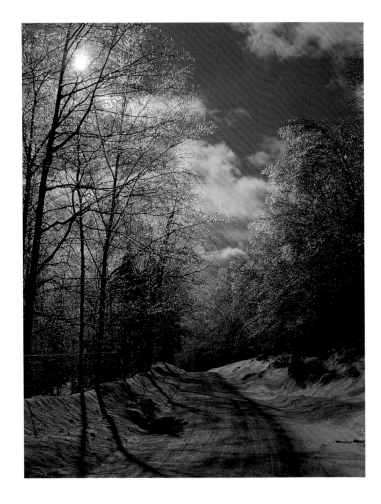

Cleveland Road, North River.

County. Ben Cleveland is a living volume of American history.

His own history is as interesting as it is long. Although born in Johnsburg, Ben's father John moved the family to North River in 1904 when he was offered a job as a teamster for Frank and George Hooper, the original owners of the local garnet mines. Ben's family lived for a time in housing provided by the mining company, but later John and his wife Elizabeth moved again to a farmhouse on Cleveland Road. As a young man, Ben was highly regarded for his marksmanship. In fact, according to his daughter Beatrice, he was fond of jokingly saying that he single-handedly won the First World War. "Daddy was in the U.S. Army and was still on

a troop ship bound for Europe when the war ended. But he used to tell anyone who asked about his army career that, when the Kaiser heard Ben Cleveland was on his way over, the Kaiser just surrendered!"

You don't live to be a hundred years old by being weak, and Ben is not weak. Genevieve recalls growing up under his guidance. "My father was regarded by some as a very stern person, and I guess he was in some ways. His word was law. If we asked for something and he said no, we never asked a second time. He spoke his mind but was always honest." Ben learned to work many kinds of jobs as he raised his family. Like most of his contemporaries, he was skilled at carpentry, mining, guiding, logging, and farming. In the 1920s he bought a farm across the

river from where the Barton's Mines Road is today. Then, as now, there was no way to cross the river except by paddling across the rocky rapids in a small boat. Nonetheless, he raised horses, cows, sheep, pigs, and chickens while his oldest daughter Elizabeth had to be rowed across the river every day to attend school. During the Great Depression of the 1930s, Ben's skills as a "river driver" kept his family fed. Anyone today would consider this job suicidal, and many drivers of the enormous rafts of logs destined for the paper mills of Corinth and Glens Falls did lose their lives in the process of breaking up massive log jams or by drowning in the rivers icy currents. To Ben it was just another job. "Times were hard during the Depression," recalls Genevieve, "but not once did his family go hungry. He never had financial help from anyone." He finally moved the family back to civilization on the other side of the river, building a quaint but sturdy house on Barton's Mines Road where he and Beatrice still reside. In 1935, his wife Elsie gave birth to

Genevieve, and Ben delivered her himself. Years later he would tell Genevieve, who was training to become a nurse, that delivering newborns was easy. "There's nothing to it," he told her. "You just have to catch the baby!"

Ben was eighty-one when Elsie died in the fifty-fifth year of their marriage, now over twenty-two years ago. His devoted daughters have willingly looked after him ever since. Genevieve reflects on growing up with her father:

I know that he appeared stern to others, but he had a very gentle side. I remember once before I was old enough to go to school, he was cutting hay with a scythe and snath. He stopped for a break and we sat together on the hillside. I looked at his hands and said, "Daddy, when will my hands be as big as yours?" He took my hands in his and said "Your hands will never be as big as mine because you are a girl." He expressed a lot of love and tenderness to us when we were growing up and helped us after we were grown too. We're happy to do the same for him now.

HAROLD ROSS

Bakers Mills Farmer

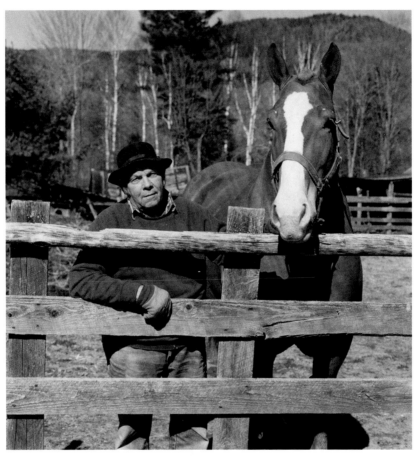

Harold Ross with Gingersnap in Bakers Mills, April 1997.

Harold is the fourth generation of his family to live in Bakers Mills. The farm he inherited from his father is near Ross Lake, named by his great-grandfather in the nineteenth century. Over the last fifty years, Harold has made a living as a miner, farmer, logger, and handyman in North Creek in order to keep the farm in the family. His love for the land that he inherited is quite obvious. He spends most of his time planting, cultivating and harvesting potatoes, and maintaining a corral for his trusty drafthorse Gingersnap. He also wages an ongoing cold war with the beavers that constantly try to flood the stream that runs along the edge of his farm. Although he is happiest when there is work to be done outside, his wife Isabelle also requires his attention in the farmhouse. For many decades, she was happy to play the role of farmer's wife, but her failing eyesight has forced

Ross Lake, named for Harold Ross's ancestors.

Harold to learn new skills in the kitchen and the rest of the house in recent years.

Having heard from many citizens of Bakers Mills about his quaint farm and the common sight of Harold and Gingersnap giving rides to the local children on an old wooden cart, I had to see the place for myself. I had the chance one crisp April morning on my commute to the North Creek Health Center, so I dropped by and found Harold as expected in the farmyard with "Ginger." He was more than happy to let me photograph him with his four-legged friend, as long as I didn't keep him from his chores too long. Not being familiar with cameras or especially posing for one, he had rather low expectations for the results. It was a thrill for both of us when he saw the results, and he paid me the ultimate compliment when I asked him how he liked them. "I wouldn't take five hundred dollars for them!" he exclaimed.

WINIFRED YOUNG

Granville Mother

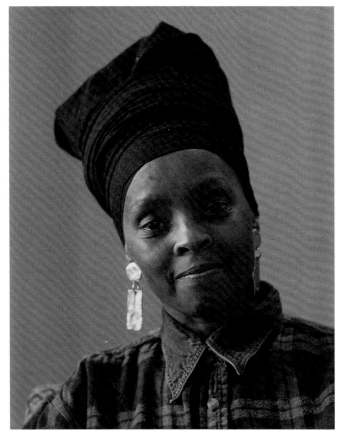

Winifred Young, April 2003.

Taking night call for medical emergencies is never a fun thing under any circumstances. Even after twenty years, when my beeper jars me awake from a sound sleep at 2 A.M. and I see the ER's number glowing on its LCD screen, a wave of emotions washes over me. First, there is confusion and disorientation, followed by anger and frustration, which gives way to resignation and determination. If, as I quietly walk out the back door, I am met with subzero cold or falling snow, it only adds to my self-pity. Usually the experience is something to be endured.

It proved more than that very early one April morning in 2003 when I was asked to come in and evaluate a forty-eight-year-old woman whom I had never seen before and who was a patient of one of my colleagues at our Glens Falls Health Center at Broad Street. The emergency physician told me she was suffering from severe diabetic ketoacidosis, which as any medical doctor knows is an acute, life-

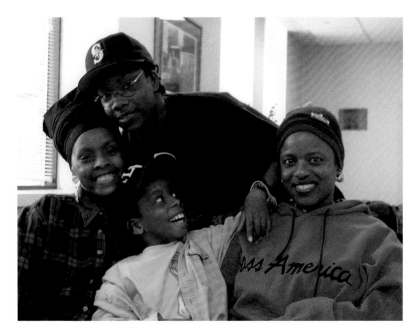

Winnie with sons, Gabriel and Robert, and sister, Judy.

threatening crisis where a lack of insulin causes the diabetic patient's body to burn fat instead of sugar for fuel. This metabolic catastrophe allows unused glucose, organic acids, and acetone to build up in the blood as though the patient had been injected intravenously with a combination of syrup, vinegar, and nail polish remover. Although I had treated many cases before, I knew at the very best I would be up all night in the intensive care unit near the patient's bedside ordering various combinations of IV fluids, insulin, sodium bicarbonate, and other electrolytes while monitoring hourly blood tests until the patient's metabolism was restored to a safe balance. I didn't want to think about the very worst.

After wiping the sleep from my eyes, I got up and dragged myself into the Glens Falls Hospital ER where I came upon a frail-looking, desperately ill black woman who was moaning and restless, but otherwise unresponsive. She smelled like Wrigley's Juicyfruit gum from the acetone on her breath. Her sister Judy, looking very worried, was at her bedside. From Judy I learned that Winifred Young was a native of Albany who lived in Granville with her hus-

band and three children. She added that Winifred had no health insurance and had not been a Hudson Headwaters Health Network patient for over four years. "Then who prescribes her insulin?" I asked. "She got a bottle at the Albany Medical Center three months ago and she's been trying to make it last ever since." As I pondered the significance of this fact she looked up at me with a look of desperation and asked softly, "Can you help her doctor?" As I returned her gaze, I didn't have the heart to tell her that, technically, I was not responsible for a patient who had not been seen by one of my group's physicians within the past three years. It would have been easy to walk away and tell the ER doc to call the M.D. who was responsible for unassigned patients that night, but I couldn't. Instead I nodded yes, and explained that her sister had gotten this sick because she wasn't getting enough insulin and was critically ill, but that I knew what needed to be done and would do all I could for Winifred. Her relief was palpable. "Thank you sir," she said earnestly.

After four hours, six liters of IV fluid, over eighty units of insulin, two amps of bicarb, and a lot of

work by a team of dedicated nurses, Winifred began to come out of her coma. I watched from her bedside as she opened her eyes and began looking around, trying to orient herself. As weak as she was, there seemed nonetheless an intangible sense of grace about her. Perhaps it was the sincerity and concern her sister had shown on her behalf that made me notice. Finally, her eyes locked on me and she asked, "Are you my doctor?" "Yes," I answered. "What's your name?" "My name is Daniel Way. It's good to see you feeling better." With all the strength she had left, she whispered, "I *am* feeling better. God bless you, Daniel Way." She then fell asleep.

Her simple words uplifted me, as if a window had been opened, letting in a draft of fresh air. A moment before I had been exhausted and in need of a large infusion of caffeine to prepare for the morning's rounds, but now I felt inexplicably energized. Winifred had reminded me that it *was* a blessing to be able to heal the sick and help make people's lives better. That was why I went into medicine in the first place. Rarely in my experience as a physician had one so ill expressed her appreciation so sincerely, with such effort and effect. This *was* a special lady, I thought, as I shuffled pensively down the hall.

By the time I came back to check on her in the afternoon she was already out of bed and walking around. She didn't even remember our earlier meeting, yet she greeted me with a warm smile and a friendly handshake. I reintroduced myself to her, and she replied, "I'm Winnie." I was able to learn that she had been diabetic for over half her life, yet had never suffered any significant organ damage. Many diabetics can begin to suffer heart disease, strokes, retinal, and nerve damage in less than ten years, yet Winnie had endured none of these problems. She beamed when I suggested it was her positive attitude. "My Momma gave that to me when I was very young. She always told me to love myself and see the beauty in other people. Did you know

that *you* are beautiful?" I glanced over my shoulder to see if someone was standing behind me while she continued. "Everyone is beautiful in some way." The most amazing thing was that this was no act by some burned-out flower child. She was utterly sincere.

The next day, as our conversation shifted from educating Winnie on the dangers and management of her insulin-dependant diabetes to the barriers her self-employed husband was encountering in his attempts to find affordable health insurance, her two sons appeared with their aunt. The respect and affection they lavished on their mother was touching and refreshing. (I learned from Winnie that her ancestors were among the first five black families to settle in the city of Albany in the 1880s, and her sense of family pride was obvious.) Suddenly, I knew I had to try and capture the grace of Winnie's character and the strength of her family's love on film. Although she had only known me for a couple of days, she freely consented to let me take some pictures of her enjoying the company of Judy, Gabriel, and Robert on the day she was to go home. Meanwhile, we continued discussing the support that would be coming from the hospital's nutritional, case management, and social services departments.

Soon the day came when she was to be discharged back to the care of her outpatient physician, my colleague Gerald Schynoll, who had not seen her in almost four years. As I framed Winnie and her family in my viewfinder, I pondered the events of the past few days, starting with the unwelcome buzzing of my pager in the middle of the night. The amount of time I had spent providing medical care to Winifred Young? Perhaps six hours. Cost of her four-day stay in Glens Falls Hospital for the treatment of diabetic ketoacidosis? $6,487.37. Value of meeting and briefly knowing a charming and, yes, beautiful human being whom I was able to help survive a difficult situation? *Priceless.*

EARL ALLEN

Bakers Mills Rake Maker

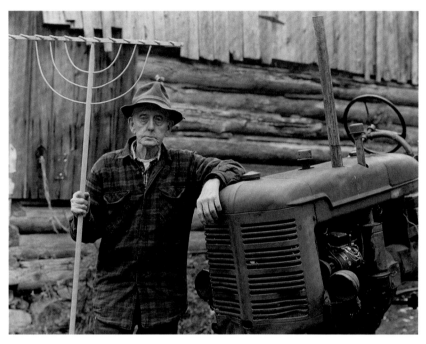

Earl Allen with rake and vintage tractor, October 2002.

Earl Allen was born in the wrong century. At age seventy-eight he clearly prefers the technology that prevailed in the late nineteenth and early twentieth centuries. In fact, he has surrounded himself with it in his Edwards Hill Road shop in Bakers Mills. His collection includes enough old tools and motors to fill a modern hardware store, and most of them are older than Earl is. More amazing still is the shop itself, which is over 100 years old and includes a sawmill, a blacksmith forge, and machine shop. Even now, as it was when Earl bought it from his Uncle Delbert in 1959, a 1930 Model A Ford engine powers the saw blade. Meanwhile, the machine shop, which was built in part to manufacture wooden hay rakes, relies on a one-cylinder, hit-

or-miss Sears & Roebuck engine found in the 1910 catalogue. Forty-five years later the only change in Earl's shop is some newer wiring and an additional generation of tools.

Even though John Deere wiped out the commercial market for wooden hay rakes when Earl was a young boy, he produces them, nonetheless, just as his uncle and grandfather did before him. "If I don't do it," he asks reasonably, "who will? No one else has the original tools to make a hay rake that is identical in every way to those made a hundred years ago. Besides, there are still people who will pay $20 apiece for 'em. That's more than Montgomery Ward used to get." He sells the rakes to various specialty shops and catalogue companies, but he does it mostly be-

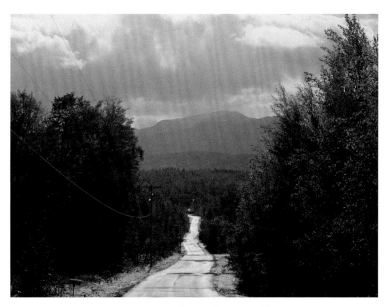

Crane Mountain from Edwards Hill Road.

cause he cares about the old tools and motors, and it makes him sad to think that he may be the only person who still has the knowledge and experience to use them. "Young people aren't interested in this kind of thing anymore," he sighs. "I doubt I could sell this mill if I wanted to." Although devoted to their father, his own children are no exception. "They all got families and lives of their own." He's right.

I had heard about Earl's hay rake factory from a number of patients, and he was eager to show me around. He demonstrated how, with some coaxing and sweet-talking, he could still fire up the old Sears & Roebuck motor. Its peculiar one-spark-for-every-four-cycles timing created a quaint and very measured "chug, tok-tok-tok, chug, tok-tok-tok" rhythm that turned a shaft, which he lowered onto a belt, which turned another shaft, which turned some gears, which operated all the tools used to make the parts of the rake. A twelve-bit boring machine would simultaneously drill a dozen holes in each rake head, while his vintage lathe would create the handles. A milling machine shaped the stales or

teeth. The six curved bows that support the handle and head were formed by winding green branches of white ash around a wooden drum for several months, then cutting them to size before fitting them in place. Not content to merely shape and assemble the rake's pieces, Earl uses wood grown on his own property, which he cuts with his own chainsaw, snags and skids with a vintage 1946 tractor, and cuts in his own sawmill!

His ability to make these archaic tools is more than a labor of love, as I discovered during my visit. It also keeps Earl remarkably healthy. Oh, sure, he comes to see me at the North Creek Health Center once or twice a year for a routine appointment, but his health is so good that his visits are more social than medical. But as I watched him climb up the back of his tractor to perch on its well-worn seat, I was amazed at his agility. He was able to pull himself up and swing his leg over the seat in one smooth motion that recalled the Lone Ranger leaping onto his trusty steed Silver. I almost expected him to ride off yelling, "Hi-yo Silver, awaaaaaayy!"

THE TURNER BROTHERS

Indian Lake Truck Fanciers

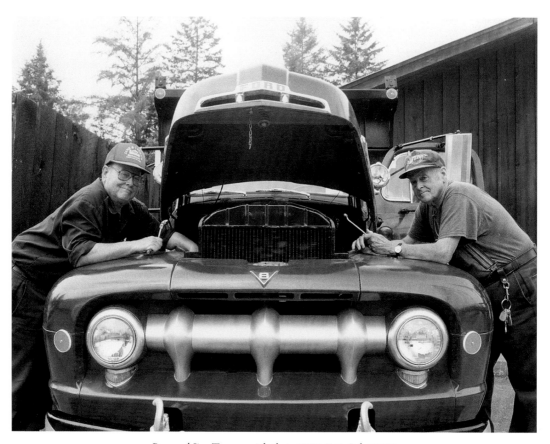

Roy and Jim Turner with their 1951 F-8, July 2003.

It wasn't long after Harriet and I started raising a family that she began referring to me as her "biggest child." She used this description when she would catch me playing with my "toys" (i.e., my Stoddard collection, Spiderman comics, or my many cameras) instead of focusing on my more mature duties (i.e., mowing the lawn, washing the dishes, fixing the toilet). Although it is meant to encourage a more responsible attitude, I consider it a compliment. After all, why completely let go of your childhood if you don't have to? I think that's why I get such a kick out of the Turner brothers. They never completed their childhood either.

Most boys become fascinated with vehicles such as cars and trucks at some point. For Roy and Jim Turner, it was inevitable because their father owned a construction firm in Indian Lake. Among Turner Construction's assets were a number of trucks, and when Jim was of age he joined his father in the business. "When we weren't pouring concrete founda-

tions and building houses," he recalled, "we were hauling gravel, logs, wood pulp, and anything else that needed transport from one place to another. We owned dump trucks, pickups, and flat beds. I worked with trucks for over forty-five years, and we got pretty good at fixin' them when they broke down." Roy, twelve years younger, later joined the business on a part-time basis while also driving school buses for the Indian Lake Central School for over thirty years. "We've been working on trucks since we were kids," he once told me, "and I'll tell you they don't make 'em like they used to. You never saw plastic on a truck back in the 1950s!"

Both men are patients of mine, and I couldn't help noticing that, regardless of why they came to see me, the conversation inevitably gravitated to talking about trucks. Even Jim's wife Rita, when she would come in for a visit, would pass along an update from the boys about how "Jimmy and Roy" were off to another truck show somewhere. Apparently, even after their long careers driving trucks had ended with retirement, they still liked to play with trucks. Active members of the American Truck Historical Society, they did indeed travel all over the northeastern United States, attending shows where they would search for spare parts and admire the vintage trucks of other men in the ATHS. ("There aren't many women in the society," Roy admits. "It's pretty much a man's thing.")

One day Jim came in to my office very excited about a truck that he and Roy had found in need of "a little fixin' up." This enthusiasm reminded me of the way I felt back in the 1960s when I would open a pack of Topps baseball cards and find Mickey Mantle looking back at me. "You outta come down to the garage and see it; she's a beauty!" How could I resist?

A few days later I stopped by Meyer's Central Adirondack Garage in downtown Indian Lake, just south of the Bear Trap Inn, where I found the two boys standing on inverted milk crates bent over the engine of their new toy. "Tell me what you've got here, fellas," I declared. "Why this here's a 1951 $3\frac{1}{2}$-ton Ford F-8," said Roy. "It's the biggest truck Ford made that year. It was a fire truck for the Bolton Fire Company for many years, until it was bought by a farmer who shortened it up and put a platform dump on it. It had been sitting in a garage for seven years and had only 20,000 miles on it when we picked it up for $1,100. Yessir, the fire company took real good care of it. Back in 1951 you had real craftsmen building these things. This vehicle here will outlast any truck made today."

The two brothers were clearly enjoying each other's company as they tinkered on the Ford's V-8 engine. They reminded me of two kids playing with Tonka trucks in a sandbox, except that this truck was a 16,000-pound toy they had spent over 500 hours working on. "You guys seem to get along pretty well," I observed. "Well, yes and no," Roy replied. "You know how brothers can be. At times we get along, and other times we're quite far apart. But we always manage to get back together and continue on." He estimated that over the past half-century they had worked on at least twenty-five trucks. "We still get a kick out of it, just like when we were children." Watching them work, I realized that they epitomized my own Confucian philosophy, which says: "You can only be young once, but you can be immature forever!"

ALICE & LESTER STERNIN

Minerva "Flatlanders"

Les and Alice Sternin of Minerva, July 2000.

Like many of my patients, Alice and Lester Sternin came to the Adirondacks from the metropolitan area that surrounds New York City. I have always found it interesting to learn how or why people from the most developed and sophisticated urban region on earth can end up in a place as remote as the outskirts of Minerva in the Adirondack Park. Although the Sternins only had to move about 240 miles as the crow flies, they left Roslyn in Nassau County for an area that is almost devoid of any stores other than a gas station, small grocery, and an outdoor sporting goods store. *Why?* "I guess we just fell in love with the place," says Alice, who began

coming to Minerva from her childhood Manhattan home at age seven to attend Camp Che-Na-Wah, a girls' camp on Balfour Lake. Smitten by the camp's rustic charms, Alice returned every summer as a camper and later counselor, until she met and married Lester at age twenty-one. Meanwhile, Lester was building a successful business in Manhattan while they started a family. Even when their daughters Ronnie and Margie were five and eight years old, Alice had not forgotten about Camp Che-Na-Wah. She returned there with her girls as head counselor, eventually buying the camp and becoming its owner and director with her husband's support.

Minerva Farm.

When I asked Lester what made him give up his life in The Big Apple and move full-time to Balfour Lake in 1987, he said simply, "Alice said we're moving to the Adirondacks, and we moved, that's it!" When I expressed skepticism that he would accept such a fundamental change in lifestyle, he shrugged. "It's true that I missed the cultural assets that the big city offers, but everything is a trade-off. Since I moved up here my blood pressure is lower, it's easier, and it answers many of my needs. It was a good decision." Les maintains his emotional ties with his past life by reading almost every page of every issue of the *New York Times* and *Wall Street Journal.*

Even after selling the camp a number of years ago, the Sternins have continued to play a very active role in local affairs as members of the Minerva school board and historical society while also raising money for Dollars for Scholars. "I keep mentally active," says Lester, "that's the key to retirement. In the city there are a thousand things you could do every day and never do the same thing twice. Here, it's different. You have to *make* yourself busy. But one of the advantages of living here is that you have to drive almost fifty miles to get to a shopping mall. Not only does that save you money but also it forces you to pursue less materialistic activities. If you were bored here, you would be bored at the corner of 42nd Street in Manhattan. It's a mind set."

I get a kick out of the Sternins. I can always count on Alice's sanguine optimism, even when she had to face an aortic aneurysm repair. Lester's unflappable serenity was also tested years ago by a successful battle with prostate cancer. His unlimited supply of aphorisms is legendary. One afternoon I was making home visits in the area and so I stopped by for a visit. During our conversation, when Lester mentioned that he kept *mentally* busy, I pointed out that most people move to the Adirondacks for the *physical* activity, and I encouraged him to try getting a little exercise. That was a mistake.

"Exercise is against my philosophy," he said sardonically. "I agree with Aristotle, who said, 'sit on the bench, talk to the students and the people.' The only exercise I get is walking to the funerals of my dead athletic friends."

What am I supposed to say to that?

WILLIAM COULTER

Johnsburg Crane Operator and Fiddler

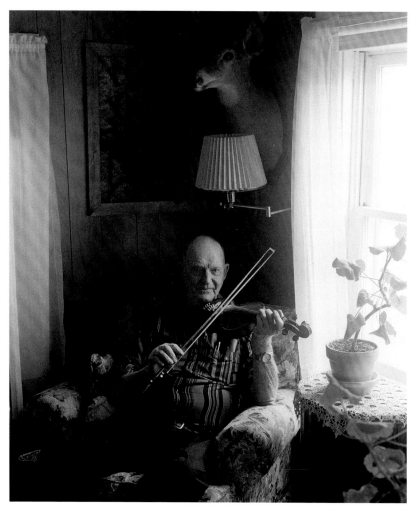

William Coulter in his Johnsburg home, October 2002.

I have known Bill Coulter for over twenty years, and I have always liked him. I think we have a lot in common. For example, we were both born in the Adirondacks and have a great appreciation for them. We are both professionals trained to perform stressful jobs, and we both enjoy the arts in some fashion. We have both worked in North Creek, and we both knew Martin Waddell! In Bill's case, he was born in Johnsburg, he knows how to hunt wild ginseng, and he had a long career as a heavy equipment operator for the Local #106 Operating Engineers. His step-grandfather taught him to play the fiddle,

which he does primarily as a hobby, but he is skilled enough to make a few bucks here and there on the side. He drove a snowplow in and around North Creek for the town of Johnsburg before joining the 106th, where he met and worked alongside Marty. So you see, we're practically twins!

Anyway, like many multigenerational Adirondack natives, Bill comes from Irish stock. Along with millions of his countrymen, his grandfather immigrated to the United States before the Civil War and eventually moved to the Adirondacks to set up a family farm. Bill's father was born in that farmhouse on Coulter Road, as was Bill himself. As a young man raising a family, Bill spent a lot of time in the woods trapping and hunting, then later learning how to hunt for ginseng. Living off the land has always been a time-honored Adirondack tradition, and at first ginseng hunting was just another way for Bill to make extra money for his family. "Selling ginseng was always a good way to make a profit," he told me, "especially when the price of furs got too low to bother trapping." Bill is a patient, quiet, modest man, which is the perfect combination for hunting ginseng. He was patient enough to learn how to find the elusive root and modest enough not to brag about where the best places were. After much prodding, he would only reveal how "all your books say it grows on the north side of a hill, but I find it best on the northeast side of hills covered with hardwood forest." He found in ginseng hunting the perfect release for the stress of operating bulldozers and cranes, and it became a family affair when he taught his children how to hunt for it. "It's something that grows on you. Once you find it, you want to find more. My wife Betty would pack a spaghetti dinner with corn on the cob, and we'd take it out in the woods. We'd spend all day hunting ginseng, then eat a nice dinner around a campfire. We had a buyer for the root in Hartford, and the kids made enough money to buy all their Christmas presents with it. Today, you can get $500 a pound for wild ginseng, but it's a lot harder to find."

A fellow ginseng hunter sold Bill one of the eight fiddles he owns today, and despite a minor stroke he suffered a few years back, he still can play all of them. As a member of the renowned Adirondack Fiddlers, he has played in every county fair in a fifty-mile radius, as well as museums, nursing homes, and many other venues. When Betty died after fifty-six very happy years of marriage, Bill found his membership in the Adirondack Fiddlers an important way to escape his grief while providing some comfort and entertainment to others. Irish jigs, reels, and waltzes are all in his repertoire, and on a crisp October afternoon in 2002, I visited his Johnsburg home to have a listen for myself.

The home was much as I had imagined it, and Bill gave me a quick tour. The walls of several rooms were covered with many pictures of his family and various fiddling gigs. In the barn out back hung over two hundred traps, and I was surprised to learn that he had caught over thirty mink the previous winter. "They still help pay the bills," he said simply. "That's why I renew my license every year." Back in the kitchen, the smoky fragrance of a pinewood fire in the stove added to the ambience as he performed "The Sidewalk Waltz" on his favorite violin. The years seemed to melt off him as his bow danced across the strings. Watching his well-worn fingers form the musical chords, I imagined them operating the heavy controls of a twenty-ton crane towering twelve stories above the landscape. It brought to mind a hair-raising anecdote that Bill had earlier shared with me of his involvement with the 1972 construction of the International Paper mill in Ticonderoga.

I had already helped a crew of American Indians set some big I-beams inside the mill. As I was lowering a ten-ton sheet of steel into the mill, a sudden gust of wind took it, and the force snapped a tag line and the whole crane started to tip over. Well, the Indians scattered in every direction, and I boomed the steel up as fast as I could, swung it over the wall of the mill to rebalance the

crane, and set it on the ground outside. It took me a couple of minutes to settle down after that!

As Bill finished his performance, I mentioned the incident and speculated that his good friend and supervisor Martin Waddell (who had passed on about three years earlier) wouldn't have let Bill forget about it. Although they were both from Johnsburg and almost exactly the same age, Marty's larger-than-life, controlling personality would have contrasted sharply with Bill's more laid-back and humble nature. Although Bill accrued over thirty-one years of experience operating bulldozers, pavers, graders, loaders, dump trucks, and cranes while working with Marty on such projects as the St. Lawrence Seaway, Adirondack Northway, International Paper mill, and the State University campus at Albany, Martin Waddell wouldn't let anyone get too big a head. "How did you two get along, anyway?" I asked. Bill just rolled his eyes, shook his head slightly, and smiled broadly. Then he picked up his fiddle and began playing another round of "The Sidewalk Waltz."

LUCIA ROSS

Olmstedville Homemaker

Lucia Ross at her Olmstedville home.

If you just met Lucia Ross for the first time, the last word you would use to describe her might be "strong." After all, she is eighty-five years old and weighs about seventy-two pounds soaking wet. If the meek were to inherit the earth tomorrow, she would probably inherit an entire continent of her own. She has a mouse-like demeanor and wouldn't hurt a fly even if she could. And yet, having known her for almost fifteen years, I can truly say that against all odds, Lucia Ross is one of the strongest people I have ever met in my practice. Most of us

gain strength from our everyday lives. We gain strength from the goals we accomplish and from the freedom to pursue our dreams. And we gain it from the love and support we receive from the other people in our lives. Imagine having to find the strength to survive, let alone find happiness, in a world where love is almost totally absent and freedom does not exist. Yet Lucia has.

One of eight children, Lucia can recall some pleasant memories growing up on a three-hundred-acre farm in Geneva, New York, near Seneca Lake.

Ramsey Road near Lucia Ross's home.

Between chores, she played with her siblings, and she enjoyed the unhurried pace of her rural life. Her parents were strict Episcopalians, however, and did not give their daughter much control over her own destiny. When she turned eighteen, her father, not allowing her to gain the experience of dating boys her own age or choosing a boyfriend, decided Lucia should marry Elmer Ross, a man ten years her senior. "It was a deal where Elmer's father would sell some land to my father at a good price" she says bitterly. "I had no say in the matter."

One of her first duties as a wife was to take care of her father-in-law, a "cantankerous Scotchman" whose poor health kept her busy as a full-time caregiver until he finally died after eleven years in their house. However, it didn't take that long for Lucia to realize that the marriage itself was a tragic mistake. Her husband turned out to be exceedingly cruel, verbally and physically abusive, and utterly incapable of expressing any affection whatsoever. Upon confiding this to her mother she was summarily told, "There will be no divorce in this family!" "I was trapped," she told me with a vacant look. "There was no getting out. Where could I go? What could I do? I had to just survive. That's all."

When Lucia suspected in 1939 that she was pregnant, she couldn't bear to tell her husband because she knew that he wanted no children in their marriage. "Finally I went to the doctor, who told me I was going to have a baby. When I came home and told Elmer, he hit me so hard I flew across the room. After our daughter was born, he didn't even accept that she was alive for the first three years." Although Lucia enjoyed motherhood and had a loving relationship with her young daughter Betsy, Elmer's animosity and cruelty took its toll on the child as well. Life was hard.

Time passed. In 1958 Elmer moved his family to another farm in Olmstedville just as Betsy was eagerly going off to college at Albany State, leaving Lucia to adapt to a new environment and an empty nest. She knew no one, and she was not allowed to go anywhere or do anything but serve her husband. "I couldn't go to church. I couldn't do needlepoint, or play music, or even read a book. He'd say, 'whaddya want to waste time doing that for?' He never did anything either. He wouldn't bathe; he'd just sit there in a chair in the corner all day, every day. But if I didn't get meals ready on time, I'd hear about it." When Betsy came home to visit, he would completely ignore her. Eventually she stopped coming home.

Elmer's apathy about the state of his own house left the responsibility of its maintenance and beautification to Lucia. It was the only thing in her life that gave her any pleasure. She painted, wallpapered, and decorated the house; mowed the lawn; and tended the vegetable garden. She literally put her heart and soul into her work so that, over the years it seemed as thought the house, and the land it stood on, had become an extension of her. Perhaps Elmer sensed this, and in 1993 he couldn't bear to live in the house any longer. After sixty years of enduring his abuse, "one day he told me 'I never want to see you again,' and left. He hit me with his cane on the way out the door." He moved into Montcalm Manor in Ticonderoga, where he died a bitter and lonely man six years later. At last, she was free.

Even after her ordeal had ended, Lucia invariably appeared frail and sad when I would see her in my office. She would describe the nightmares that would still wake her up screaming, "Don't hit me!" Public health nurses would entreat me to find out why she was so thin and do something about it. Knowing she had been as thin as a beanpole for as long as I had known her, I held no illusions that she could be fattened up somehow. Yet, I *was* concerned that, at eighty-five, she might be too isolated and overwhelmed to be able to go on living in her remote Essex County farmhouse. True, Betsy had moved back home eventually after her father's death, but she had a full-time job in Lake George and was at work all day. Therefore, on a beautiful May morning in 2002, I accepted Lucia's standing invitation to come for a visit and followed the directions provided by my physician assistant Bill Connor who had visited her in the past. "Make sure you bring your camera too," Bill advised. "You'll be glad you did." He was right.

After only a couple wrong turns and a great deal of rubbernecking to take in the pleasing roadside scenery along the way, I eventually arrived at her stately country home to find Lucia waiting at the front door. The first thing I noticed was that, despite its age, the house was as neat as a pin. It had a new roof and had been recently painted. She took me on a walking tour of her property, crossing a small wooden bridge en route to the vegetable garden she had planted, already sprouting the season's first seedlings. There were no weeds to be found. Then we walked to the barn, where she showed me the riding mower she still operated herself. Her gait was cautious but steady across the soft, uneven ground as we made our way back to the house. I was beginning to realize that she appeared much stronger and more confident than she had ever seemed before. Inside, she showed me all the home improvements she had made over the years, and Betsy's beautiful art adorned the walls. It was clear that, especially since Betsy's return, this home

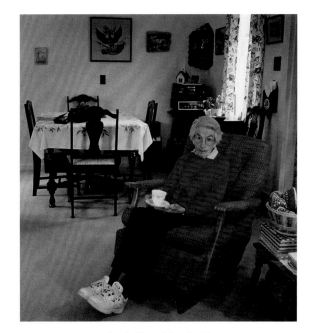

Lucia Ross, May 2002.

meant everything to Lucia. It was her whole world. As I looked out the living room window at the tall trees overhanging a babbling brook in her yard, I found myself agreeing with John Ruskin's definition of home: "It is the place of peace; the shelter not only from injury, but from all terror, doubt, and division."

After a visit that lasted far longer and was more pleasant than I had anticipated, I was almost reluctant to go back to the reality of my office practice with all its paperwork and phone calls. At least I had learned what I had come to learn. I could see that Lucia's efforts over the years to create her ideal of home had exorcised an abusive spouse from her domain as though he had been an evil spirit, and she had triumphed. Lucia wasn't merely okay where she was; she was in fact far stronger and more capable there than I had previously believed. As I turned to leave, she gave me a big hug, which I returned as warmly as I dared for fear of hurting her. I learned something else then. Lucia likes to be hugged.

CHUCK SMITH

World War II Pilot, Glens Falls

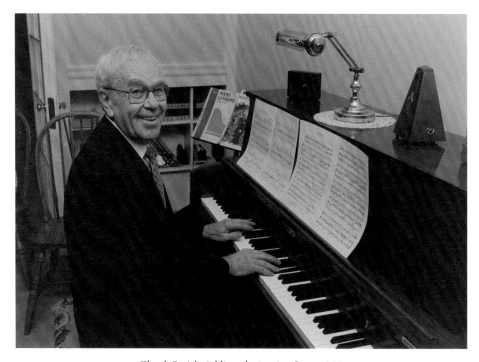

Chuck Smith tickling the ivories, June 1993.

Many of the people I have photographed are patients who became friends. Chuck is a friend who became a patient. I came to know him as the father of my neighbor Patricia Phillips, but when I learned of his military career as a pilot in World War II, and he learned of my fascination with those who fought in that war, we became fast friends. We spent many summer days talking by his backyard pool in South Glens Falls while my kids frolicked with his grandchildren. As he shared his astonishing memories of seemingly countless brushes with violent death as a young man, I found myself transported so far away from our peaceful surroundings that I could barely relate to them. This weather-beaten old man with the craggy face, soft baritone voice, quick belly-laugh, and "aw-shucks" demeanor was not only a true American hero, but he seemed to have lived more lives and cheated death more times than anyone I had ever heard of, much less known.

As a twelve-year-old growing up in Seattle, he was taught to fly the old World War I Curtiss Jennies by his barnstorming uncle, who was one of the first pilots licensed in the state of Washington. As a thrill-seeking teenager, his first brush with death came when he decided to find out how fast he could drive a car. His car hit a rock and began cartwheeling down the road, and he escaped an early demise

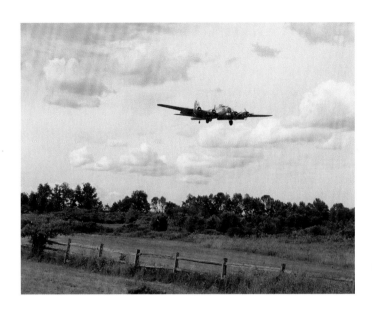

B-17 approaching Glens Falls.

by diving to the floor and hugging the pedals until the car stopped rolling. He crawled out of the wreck unscathed.

When America was drawn into the Second World War, Chuck was already a very experienced pilot. He was eventually certified to fly every type of aircraft in the U.S. arsenal, and he flew them all. In the skies over an air base in the Midwest, he lost power in his single-engine P-39 Airacobra, and when he tried to bail out as the plane went into a steep dive, he found that the canopy was stuck. He was trapped! Thinking fast, he was somehow able to use the increasing airspeed of the falling plane to jump-start the engine, and he landed the plane safely to the astonishment of his peers who watched helplessly from the ground.

Chuck's first combat assignment found him at the controls of a B-17 Flying Fortress in the 100th Bomber Group of the 8th Air Force based in Norfolk, England. On one mission over Schweinfurt, Germany, in August 1943, his bomber took devastating hits from antiaircraft guns and German fighters, which killed half of his ten-man crew and knocked out two of his four engines. He was able to limp back across the English Channel, losing an-

other engine along the way. As he approached his airbase, his fuel ran out. He still had a stone fence between his plane and the runway, but in a desperate maneuver he bounced the shattered craft off the English turf and over the wall; the plane smashed down on the tarmac with such force that it drove the left landing gear up through the plane's wing, causing the bomber to spin like a huge top as it came to a halt. Amazingly, Chuck walked away from the wreck with four grateful crewmen. "Eighty-five planes left England that morning," he told me, "and only six came back. We were luckier than most." Shortly after that mission, he discovered that his 8th Air Force assignment had been an administrative error, and he was reassigned to the Pacific theater, where he would fly B-24 heavy bombers and C-54 transport planes over "the hump" of Himalayan Mountains that separated China from India.

On the way to his new assignment, Chuck almost died again. While ferrying a B-17 from Long Beach, California, to Jackson, Mississippi, he was caught in a powerful thunderstorm. The winds were so violent that, by the time he landed the mighty plane, its wings had been warped so that their aluminum skin was crumpled like a washboard. While

Chuck Smith with an old friend.

in Mississippi, he learned that, on a mission to Münster, Germany, involving the "Bloody 100th," only one plane from his former group out of thirteen returned to base safely.

On one of his earliest missions in a C-54, Chuck had to land the cumbersome four-engine plane carrying a load of aviation fuel onto a tiny airstrip that had been carved out of the jungle on some remote South Pacific island. The problem was that American marines were still building the airstrip while battling Japanese forces lurking in the forest! He, therefore, had to bring the heavily-loaded plane down under fire and barely came to a stop at the "friendly" end of the runway, only to find himself surrounded by angry Seebees fuming that his heavy craft had ruined much of their work in progress. He then had to help unload the C-54 and take off from a torn-up runway that was too short and was surrounded by tall trees hiding Japanese snipers! Knowing exactly what he could get out of the plane

and having an unshaken faith in his own ability, he roared down the runway, ignoring the flashes of enemy rifle muzzles trying to bring him down. As he pulled as hard as he could on the controls, the ship's landing gear clipped the treetops as it hurdled reluctantly into the thick tropical air.

Chuck was flying the same unarmed C-54 solo across The Hump carrying a cargo of empty 55-gallon aviation fuel cans when three Japanese Betty single-engine attack bombers ambushed him by firing powerful 20-millimeter cannons from their noses. "They were trying to hit the fuel tanks in my wings," he recalled, "but the enemy pilots didn't realize that my plane had self-sealing fuel tanks. If they had hit the drums full of fuel vapor in my fuselage, I would have exploded like a firecracker on the Fourth of July!" Again thinking fast as his plane shuddered under the impact of dozens of cannon shells riddling his wings, he radioed for help and was able to play hide-and-seek in the clouds until a

squadron of American P-40 Tomahawk fighters arrived and easily shot down the suddenly out-matched Bettys.

Many hours later, Chuck landed in India, so exhausted that he didn't even examine his plane until after a night's sleep. He awoke to find that his ground crew had counted over 150 holes in the big Douglas transport. It never flew again.

Not long afterwards, while driving his Jeep along a dirt road in India, Chuck's vehicle suddenly began jumping all over the road, and before he realized the cause, he was thrown into a mud-filled ditch with the Jeep crashing down on top of him. Suffering only cuts and bruises as he crawled out from under the wrecked vehicle, he realized that he had just survived a major earthquake that killed many people in a nearby village. He seemed to be unbreakable. As we lounged by the pool, I asked Chuck how he managed to escape death so many times. With a distant look on his face, he replied simply, "I guess it just wasn't my time yet."

After his military career, he gave up flying for the sake of his family and pursued a long career as an engineer for an energy company in Seattle. Upon retiring years later, he moved east with his wife Stella to be close to Pat and her family. A lover of music and blessed with a rich baritone voice, Chuck played piano and sang in various groups ranging from The Master Singers of Glens Falls to a church group that held services in the nearby maximum security prison. As I sat next to him, it seemed to me as if every moment of his life had been an event of some significance.

One day in June 1993, I learned that three World War II military aircraft were coming to the Floyd Bennett Memorial Airport near our homes in Glens Falls. I could hardly contain myself as Chuck and I toured those magnificent airships, which included a PBY5A Catalina seaplane, a North American B-25 Mitchell medium bomber, and a B-17G Flying Fortress, similar to the plane that got Chuck back safely to England from Schweinfurt a half-century earlier. He seemed to genuinely love the sight, smell, and feel of the huge warbirds, as if they had met before. While I was taking his picture in front of the B-17, he impulsively reached up and grasped the 50-caliber machine gun on the plane's chin, almost as an affectionate embrace, like someone shaking hands with an old friend. I will always remember that moment.

JAMES MILLINGTON

Trapper and Gardener, The Glen

James Millington of The Glen, July 1987.

Jim was a lifelong trapper, and one of his earliest memories was learning to remove the smell of skunk from his clothes when he would bring one home from his trap line. "You take some dry twigs and get a good blaze going," he once told me. "Then break off some hemlock or pine branches and throw 'em on when the flame is good and high until it makes a lot of smoke. Then you take a good deep breath and stand right in that smoke, and that smell will come right off. We used to get two dollars for a nice skunk pelt; boy, we were in the money!"

Born in Johnsburg in 1908, Jim operated heavy equipment for the highway department for thirty-one years until a snowplow accident left him blinded in his right eye in 1972. After retiring, he spent all his time hunting, fishing, trapping and gardening from his home below The Glen.

Until a few years ago, Jim would trap fox, coy-

Jim Millington's tools of the trade.

ote, raccoon, bobcat, mink, fisher, and muskrat during the fall and winter months. Occasionally, he would find that a hunter had taken one of his traps. His usually jovial voice hardens when he thinks about it. "It's a bad business when someone takes one of your traps." He once chased a young thief several miles through the woods before losing him. Jim was only seventy at the time.

During the spring and summer months, when not fishing for trout or pike, Jim could be found working a 10,000-square-foot garden, growing cucumbers, zucchini, sweet corn, peppers, yellow string beans, tomatoes, carrots, beets, kidney beans, cranberry beans, peas, and parsnips. He begins picking peas in mid-July, and by late August he is selling vegetables along the roadside in front of his home on Route 28. His green thumb seems to have been passed down from his mother, and he still can recite some of her quaint garden truisms, such as "wet May, barn full of hay" and "good corn weather is when Granny sleeps without her nightie."

Although Jim is best known for his many outdoor skills, his physical resiliency has become a matter of legend as well. He has always been an active, robust man despite his advancing years, and it seemed that he would never show the effects of his age. In 1986 when he was seventy-nine, he developed a gangrenous gallbladder followed by a blood clot in his left leg that almost killed him. He had lost thirty-five pounds; "I felt as weak as a newborn kitten, but I wasn't through livin' yet. I still had some fish to catch and some traps to set!"

Sure enough, he fought his way back, regained all the lost weight, and rebuilt his strength. Just five months after Jim had been too weak to walk, he caught a nine-pound pike and was pictured in the *Warrensburg–Lake George News* with it. I took his picture soon after he caught that pike; he had just finished repaving his driveway and planting his garden. The same jolly laugh was still there, and so was his handshake, like, well, a steel trap!

KENT & KEITH WALDRON

Father and Son, Chestertown

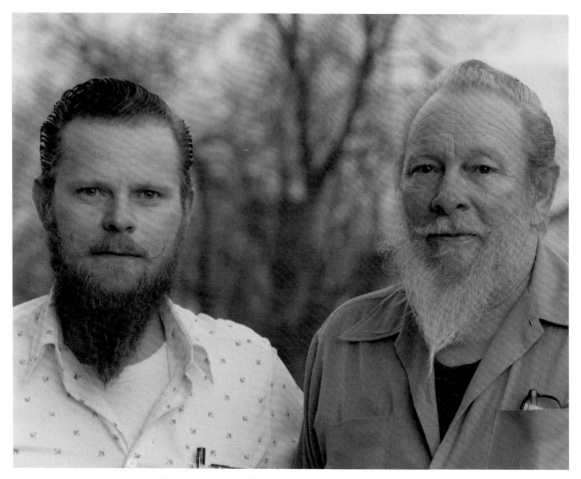

Kent and Keith Waldron of Chestertown, October 1989.

Unlike most of my subjects, these gentlemen were not patients of mine but rather the husband and son of a patient I was caring for in Glens Falls Hospital. When I first met them, I was immediately impressed with their matching Van Dyke whiskers. Later on, I was even more impressed with their concern about the person they would visit day after day from their home in Chestertown over forty miles away. In an era where parenting is becoming a lost art, it was nice to see a father and son so close to each other and so devoted to the welfare of the woman they called *mother* and *wife* respectively. Their mutual esteem was a source of obvious pride to both of them, which I wanted to capture on film.

GRACE HUGGARD

North Creek Political Activist

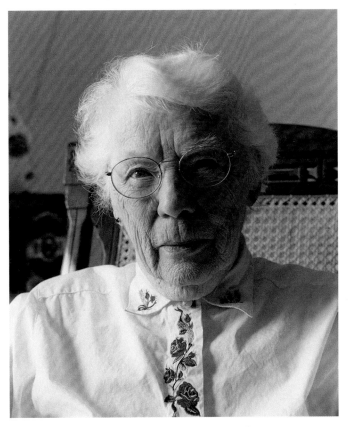

Grace Huggard of North Creek, September 2000.

There is more to Grace Huggard than meets the eye. At first glance, Grace Huggard appears to be the quintessential kind-hearted widow who enjoys showering her great-grandchildren with keepsakes and affection. Closer inspection would confirm this, but would also reveal more than just a ninety-three-year-old great-grandmother. Behind her inquisitive and perceptive blue eyes is a political activist, a gold medal pentathlete, a champion of women's suffrage, and a warrior in the battle against hunger. Happily for me, she is also one of the most

delightful ninety-three-year-olds I have ever had the pleasure to see at the North Creek Health Center. The first time she came to see me, her charm and composure seemed to beckon to my camera, and she kindly indulged me when I asked if I could photograph her. One day over tea she told me a little about herself as I deployed my Bronica.

When Grace was a child growing up in the Bronx, her world was a far different place than it is today. Women weren't allowed to vote, and it wasn't until she was a precocious twelve-year-old in the

eighth grade that girls were allowed to participate in competitive sports in New York State's high schools. As luck would have it, it was her own school's principal Frederick Riley who helped convince the state school board to allow women to engage in athletic competition. Grace wasted no time taking advantage of the opportunity to compete when she became perhaps the first high school gold medal winner of the women's pentathlon in New York State. (She has long since given the medal to her great-granddaughter Payton.) It was at about that time that the Nineteenth Amendment to the United States Constitution was passed, which allowed women to vote in national elections. This conjunction of events left a distinct impression on the young Grace that all things were possible for an American girl in the 1920s.

After high school graduation, Grace was accepted at two colleges. However, she was given a stiff dose of reality when she realized that, as an only child with a father who traveled extensively, she was expected to stay home with her mother. Undeterred, Grace instead went to a two-year business school near home where she learned secretarial skills and entered the workforce when she was eighteen years old. During the depths of the Great Depression, after eight years of working with and around men, she married James Rowland in 1933. They settled in Sayville, New York, and had two sons together, Alan and Stuart. Just when her life began to reflect the idealized American Dream at the close of the Second World War, she experienced a severe shock. "James, who smoked heavily, just dropped dead," she sighed. "Too many cigarettes!" Her grief was tempered by a determination not to succumb to self-pity. She married Franklin Huggard a few years later, and they had a son Charles. While she was raising their sons, she became involved in the local election league during the 1950s, eventually becoming president of the Baldwin, New York, chapter of the League of Women Voters. As president she edited and published a newsletter, made many public

appearances, and became active in local as well as national political elections. "We wanted to get women out of the home and into a more active role in politics," she says matter-of-factly. "We did a pretty good job too." A few years later Grace's life took another blow when Franklin also died suddenly. Charles was only ten. Shaking her head, she recalls, "Same as the first—he was also killed by smoking." Grace raised the boys herself after that and eventually found herself alone in a large house on the Great South Bay of Long Island. She decided it was time for a change.

"When I was a girl, my mother and I would take long vacations in the mountains along the Delaware River bordering Pennsylvania and New York while my father traveled." In her melancholy, pleasant memories of mountains and forests flooded back to her, and she came to a decision. "I wanted to live the rest of my life in that kind of place. I wanted the atmosphere I had enjoyed as a child." She had friends who summered on Brant Lake in the eastern Adirondacks, and they helped her find a nineteenth-century farmhouse on a hundred acres near Garnet Lake in Johnsburg, where she moved in the early 1970s. Rather than being intimidated and isolated by her new surroundings, however, she quickly blended in. "I was always good at making friends, especially with the men!" she said with a chuckle. "Once you get to know them, the ladies want to know you too. Everybody is so nice in North Creek. I'm so glad I moved here."

Over the next quarter-century, Grace maintained an energetic role in the communities of Johnsburg and North Creek. She continued her work with the League of Women Voters and was active in the election of the current supervisor of the Town of Johnsburg. Joining the Upper Hudson Environmental Action Committee, she helped establish a food pantry for local families in need, which still functions after two decades. She has turned her farmhouse over to her son Alan and has moved to senior housing near my office. She remains active in

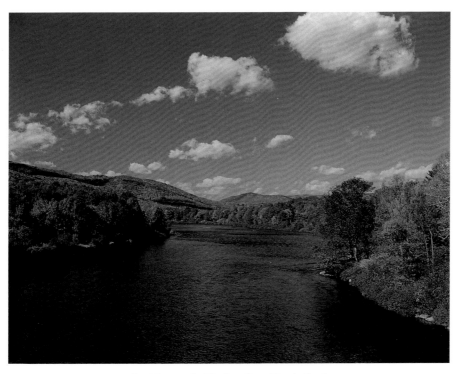

Looking up the Hudson from North Creek.

the senior citizens association in North Creek and is modestly philosophical about life. "The only thing I can think of that would describe me is that I am *adaptable,* she offered. "Whatever happened to me, I would say 'what can you do?' You have to carry on. Some people fuss a lot and can't take things. I was widowed twice; I was left alone with three children to care for. I had to change homes several times, but here I am today."

As we sat together in her cozy living room that autumn day, her cat hopped into her lap purring and looking for some affection. It found some. I asked Grace if she was happy. She looked at me patiently with an amused expression that I caught on film. "I'm ninety-three years old, dear. I wouldn't use the word 'happy.' But I am content."

ARTHUR AUSTIN

Jack-of-All-Trades, Indian Lake

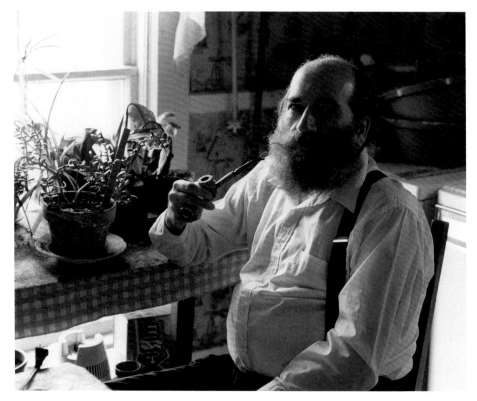

Arthur Austin in his Indian Lake apartment, May 1999.

When I was growing up in the 1950s and '60s, it used to be a cliché that, when the stresses of everyday life became too great to bear, the ideal solution would be to run away and join the circus. Well, Arthur Austin is the only person I have ever known who actually *did* it. A native of Minerva, Art is a free spirit if ever there was one. After finishing high school at the end of the 1950s, he found work at Storytown USA, the theme park below Lake George now known as The Great Escape. Within a few months his wanderlust was already getting the best of him. A minor disagree-

ment with his boss, coupled with a job offer from the Troy-based O. C. Buck Traveling Carnival while working a gig at Storytown, sent him on a thirty-year odyssey that reads like a Jack Kerouac travelogue.

I worked a carnival for a while in Ottawa where I lived in a tent and once woke up to find the drink I had left at my bedside had frozen solid. I worked for twenty-five to thirty carnivals doin' everything from putting up tents to workin' the spotlight. I lived in Ohio for a few years waitin' tables and eventually worked my way

Indian Lake from Squaw Brook.

up to assistant manager at one restaurant, but I left that job and picked vegetables at a farm in Louisiana for awhile. I was a cook in New Orleans, a dishwasher in Florida, and a bartender in South Carolina. I guess you could say I didn't care much about job security. Freedom was a lot more important to me. I wanted to live my life my own way, without anyone tellin' me how to do it.

Eventually, his sister Fran Hutchins, who asked for his help taking care of their invalid mother, lured Art back to the Adirondacks in 1991. By 1994 his mom had passed away, and he became concerned about his own health. He had been feeling increasingly short of breath for a week or more and had developed a dry cough and a fever. As it happened, I was the HHHN physician on duty the week he came down to Glens Falls Hospital, and the first time I laid eyes on Art he was a very sick man. I told him that the type of pneumonia his chest X-ray revealed was typical of patients infected with the Human Immunodeficiency Virus, and he advised me that there was indeed reason to be concerned that he might have AIDS. We, therefore, treated

him with appropriate antibiotics and antiviral drugs, and he was just beginning to recover when his HIV titer came back positive. His reaction reflected his wry sense of humor. "I think it was Mickey Mantle," he quipped, "who once said 'If I'd known I was going to live this long, I would have taken better care of myself!' "

I felt bad thinking that this interesting fellow was facing a life-threatening illness, and my experience with the few HIV patients I had treated up to that point was not encouraging. Fortunately for us both, a new class of drugs called protease inhibitors had recently been developed, and Art embraced the science and pharmacology of his AIDS treatment with the zeal of a first-year medical student. Subscribing to the sophisticated yet lay-oriented journal *Positively Aware*, Art and I developed a treatment plan that has over the years resulted in a complete eradication of detectable virus from his blood, and his immune system has been restored to essentially normal function. Art is the first full-blown AIDS patient I have ever managed who has made such a remarkable recovery.

When I took this picture in his apartment, I couldn't help noticing the plants he was carefully tending by the window; there was also a hummingbird feeder outside his upstairs porch that swarmed with as many as five birds at a time. Art seemed to have developed a high regard for life in any form and was eager to nurture it in his own way. It was as if his condition had heightened his appreciation for the simple and basic beauty of life. I asked him if his sanguine philosophy of life had been changed by his battle with HIV. "Hell, no," he replied. "If you're afraid of dyin', then life's not worth livin'. My philosophy is a lot like Katherine Hepburn's: I'm not afraid of dying, but I'm not trying to do anything to hurry it along. Most folks are so afraid of dying that they're afraid of living too. I'm not one of those people."

TED KAUFMANN

North River Water Witch

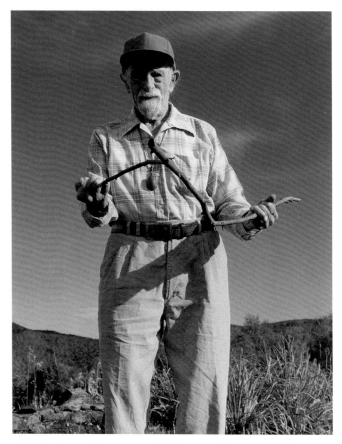

Ted Kaufmann demonstrates the dowsing technique, October 1996.

Ted Kaufmann, a world-famous dowser, is the closest thing to a celebrity in my entire practice. An advertising executive from Long Island by trade, Ted didn't even know that he possessed any paranormal talents until about the time he retired in the 1970s to live the life of a country gentleman in North River. When he discovered that he needed a new well, he was persuaded that the best way to find a new source of water was to hire a dowser. As it happened, an elderly neighbor named Edith

Lincoln was known to have such skills, and she not only successfully found water on his property but also showed him how to dowse for it himself. His interest piqued, Ted began dowsing for water on his own with remarkable success. He found to his amazement that it was no more difficult for him to sense water moving underground than it was to smell cookies baking in the kitchen from an upstairs room. The rest is history. Over the next quarter-century, his dowsing skills have become

legendary, and he has been asked to find water, as well as missing people, pets, airplanes, and even wallets. He has been featured internationally on such television programs as *20/20,* the BBC's *Strange But True,* and the Discovery Channel. A popular speaker at schools and at American Society of Dowsers conventions, Ted would spread the word about the controversial and arcane skill, which is so often dismissed by skeptics as chicanery. A humble and sincere man, he is incapable of deceit or subterfuge for personal gain. It is his character as much as his amazing discoveries that served to demonstrate the apparent existence of a "sixth sense."

Ted gave me a demonstration one late summer afternoon near his quaint South Mountain farmhouse overlooking the Hudson River valley. I was so smitten by the view that it took a while to focus on what we were there to do. He gave me a small forked branch of a cherry tree that grows in his yard and explained that, in order to be able to dowse, I would first have to relax and clear my mind of other extraneous activity, or as Ted put it, "clear out the monkey thoughts." He described the actual dowsing method this way:

When I'm looking for something, I like to verbalize my goal or objective before I begin my search. I say it, think it, and hear it, and that gives me the extra concentration to do what I want to do. I ask questions that have "yes" or "no" answers and sense the response. For example, I'll stand on the edge of a field and say "I want to find a vein of at least five gallons a minute of unadulterated water." I then pirouette with the stick in the search position and ask for a signal when I'm facing the right direction, and I get a signal. I'll then ask "how many yards is it from where I stand" and I'll get a signal. When I find the water, I'll ask, "over 25 gallons a minute?" and the stick will dip to signal "yes" or not move to indicate "no." If "yes," I'll ask "more than 30? 40? 50?" until I get a "no."

My efforts to "clear the monkey thoughts" were hampered by all the medical problems that I had

Ted Kaufmann's carriage house.

been dealing with all morning, so Ted held the stick with me and together we walked slowly across the field. He described the sensation of making a strike as anything but subtle. "When you make a find, you feel a downward pressure on the rod, and it's a feeling you can't resist. I've tried many times to keep the rod from moving, but it's impossible. Sometimes if you use a stick, the downward force can pull the bark off the wood and leave marks on the palm of your hand."

As we walked, I tried to let my mind go blank. After only a minute or so, the cherry branch began to pull our hands downward, and I felt a faint tingling in my fingers. I was pleasantly surprised that I didn't mess up his demonstration, although I still believe that the positive response was due to his ability, not mine. To me, the opportunity to share an afternoon with this remarkable old man was the real miracle, and that cherry branch rests in a place of honor on my mantle to this day.

If dowsing with a divining rod represented the full measure of Ted Kaufmann's abilities, it would be impressive enough. What he could do with a method called map dowsing, however, was what brought him international acclaim. Using a weighted object such as a plumb-bob or even a paper clip hanging from a string or chain as a pendulum, he could find anything that was within the confines of a map including well sites, missing

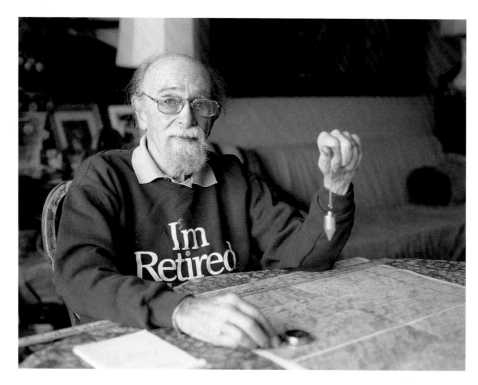

Ted Kaufmann map dowsing.

campers, lost dogs, and escaped criminals. He described the process like this:

Give me a good topographical map and a straight edge, usually a ruler, and I sweep the map with the thought in mind that I want a positive signal when the leading edge is over the person, the body, the well, or whatever. When the pendulum swings clockwise that represents a "yes" or positive signal, while counterclockwise means "no" or a negative signal. I sweep from west to east, then north to south to get a location. This is meant to be a location, not a precise spot. The size of the location can be fifty feet across or hundreds, depending on the scale of the map. That area can then be best searched by a dowser in the field.

Using this method, Ted accomplished something that would seem to prove beyond doubt that dowsing represents an actual sixth sense with extraordinary potential. He was recruited by the Warren County Sheriff's Department to help locate two men who had disappeared in a blue pickup truck in February 1981, after all attempts to locate them had failed. Using the map dowsing technique, he determined that they had died and were at the bottom of Lake George near Orcutt Bay. When the ice went out the following spring, one of the missing men's bodies washed up on shore less than half a mile from the site Ted had marked on the sheriff's map. He was then taken out on a patrol boat with divers to find the other man's remains. Standing on the front of the boat, guiding the pilot by the pull on his divining rod, he finally felt a strike and ordered the deputy to throw the anchor over the side. As the divers drifted slowly down through forty feet of cold, murky water, the sight that came into view through the gloom was beyond comprehension. To their everlasting astonishment, they had discovered that the anchor had come to rest *in the back of the blue pickup truck, with the missing man inside!!!*

ED WELLS

Bakers Mills Rascal

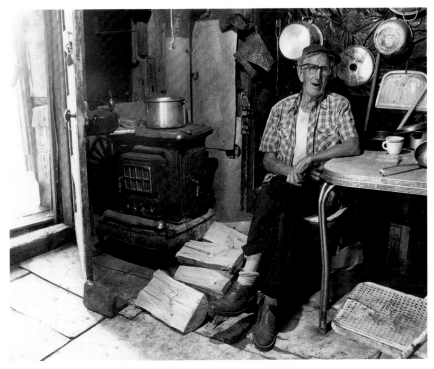

Ed Wells inside his Bakers Mills cabin, August 1987.

Eddie was a free spirit who lived for a time off Bartman Road, within a few hundred yards of his half-brother Boyd Smith. Despite his simple and remote dwelling, he followed a rather actively hedonist lifestyle, always looking for a good time at any cost. He lived through the rough and tumble days of prohibition in the Adirondacks, where he became a connoisseur of the local speakeasies. According to Drew VanDerVolgen, author of *Sea Monsters, Love Stories, and Lies: A Flatlander's Guide to the History, Humor, and Lore of the Adirondacks,* Ed was perhaps the only man in the Adirondacks ever arrested for DWI while driving a horse and

buggy! "He knew every dirty song ever written," Drew recalled with a smile. Ed himself once told me of a wild evening in Warrensburg in the 1930s when, in less than thirty minutes, he lost $500 in a poker game at Ash's Hotel. Wealth was never a priority with Ed, and I believe the memory of that night was worth the money that it cost him at the time.

Because Eddie and Boyd Smith were neighbors, I kept a promise to stop by Eddie's place after visiting with Boyd one morning. His cabin was so tiny that, even with a wide-angle lens I had trouble getting a good shot of him at the table. As I took this

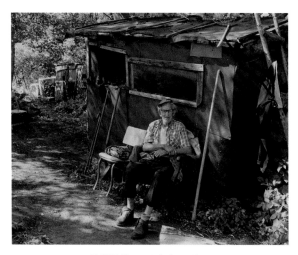

Ed Wells outside his cabin.

picture, I was leaning up against the farthest corner of the single room with the back of my head pressed against the wall. The entire building was about the size of a tool shed. His sleeping area appeared to be a tiny wooden slab in the corner. Yet, he was perfectly content.

When his colorful but self-destructive lifestyle finally caught up to him, he became a resident of the Adirondack Tri-County Nursing Home in North Creek in the early 1990s. Adapting very quickly and finding a captive audience in the mostly female staff, he became a favorite of the young aides who cared for him. His bawdy tales and naughty sense of humor are still legendary there.

From independent sources I learned that Eddie could be quite a gentleman, despite his Bohemian lifestyle. Angela Fremont, now an artist, art instructor, and consultant in New York City, could still vividly recall an encounter she had had with him over a quarter-century earlier. In a letter to me she wrote:

I spent the summer of the Watergate hearings (1973) in Johnsburg with two other couples and my boyfriend. I was a young, guitar-playing hippie from Miami, new to the Adirondacks. I met Mr. Wells while walking down the road. We talked about the woods, the weather, the wilderness, my garden, his garden. He invited me to visit his garden down the road from our rented farmhouse. I did go visit and was surprised at his modest little cabin off the road. We talked about fishing. I grew up in Florida where the fish were big, and he promised to take me fishing later in the week.

I arrived at his cabin at the appointed time and followed him into the woods. There were no paths, and the woods sometimes seemed so deep and dark that no sunlight came through. After walking for what seemed miles, we finally came to a little stream you could ford in two steps. How could this have fish in it? He gave me a pole and line with a tiny hook on it, and he put a tiny kernel of corn on the hook. In a minute we were pulling in equally tiny fish, and he made sure we moved to different areas to prevent overfishing of any part of the stream. When we had enough fish, we went back to his little cabin. There he cleaned the fish and fried them in some cornmeal that made them very crispy and delicious. He dug up a couple of potatoes from the garden and picked some green beans. We sat at his table and ate and drank and talked. He told stories, and I listened. He wondered about living near the ocean and how I managed to travel all this way by myself in the world. We weren't that different really. We both loved the beautiful world and wanted to be close to it.

My friends did not understand how I could be spending so much time with Mr. Wells. They thought it was odd. A few days later he rode up to our farmhouse on a great big horse, with another one in tow behind him. I noticed he was dressed differently. He had on dress pants, a nice corduroy jacket and riding boots. He had come calling to take me riding. It was the greatest surprise of my life! Off we went for a day of exploring the Adirondacks on horseback. I admired that he had gone to the trouble to borrow and saddle the horses; it must have taken a lot of planning. We rode past some friends of his whom he spoke to, and they smiled at us—an old man and a pretty young girl.

That sounds like Ed. He always appreciated a pretty girl and knew how to have fun. But knowing Eddie Wells, I can't help wondering what he had said to his friends that day in 1973!

CARL DECKER

North River Bluegrass Musician

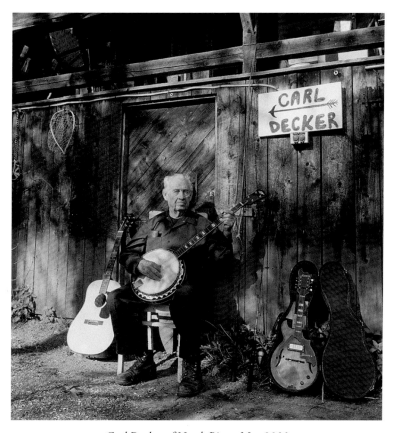

Carl Decker of North River, May 2000.

I had been Carl Decker's physician for a number of years before I discovered that he was once a locally renowned bluegrass musician. My nurse Carol Fosdick, who lives near him, mentioned it one day since Carl is far too modest to go on about himself. Once I took an interest in his musical career, however, I eventually came to learn that, in addition to fishing, music was largely responsible for his salvation after a series of crises almost took his life.

Born in Port Jervis, New York, in 1913, Carl's day job was a forty-year career in the New York Department of Highways, where he drove bulldozers, snowplows, and other heavy equipment. At the climax of his career he served over a dozen years as Greenville's highway commissioner. Still, it was his other career that he will be remembered for in the Adirondacks.

He recalls his introduction to music as if it happened yesterday.

I learned to play the guitar in 1927, when one of my classmates taught me in the eighth grade. I just had to have one of them things, so I up and bought one for three dollars from the Montgomery Wards catalogue. I couldn't wait for the mailman to come! I practiced and practiced until one day, when I was fifteen years old and sittin' on the porch, a car pulled up and a local fiddle player got out and asked, "What are you doin' tonight?" I said, "Nuthin', why?" He said, "I'll be back tonight. You get your guitar tuned up—you're gonna play tonight at a barn dance!" I said, "Who, *me?*" That 1928 square dance in Greenville launched his musical career, which would eventually include the mastering of the fiddle, mandolin, and guitar, as well as the four- and five-string banjo. In his youth he called square sets on Friday nights and weekends, traveled around the country attending bluegrass festivals, and immersed himself in the whole genre. For many years he continued working for the state during weekdays while playing his music on nights and weekends. It was not until he took on the additional responsibilities of marriage and parenthood that Carl scaled back his musical career. Nonetheless, it would serve him well later on.

Carl Decker has not had an easy life. Not only has he survived prostate cancer but he has also had to endure the untimely deaths of his wife Mary Ellen and his daughter Joan within a four-year period in the early 1970s, and then a divorce in 1986. A weaker man might have succumbed to the grief or disease, but Carl is not a weak man. Once he worked four days straight without sleep when a huge blizzard buried Port Jervis in snow during the 1950s. "I had to plow out the farmers so they could deliver the milk and keep their farms going," he recalls matter-of-factly. At the end of the fourth day he was found asleep at the controls of his bulldozer under a layer of snow with the engine still running. Looking back at those times, he shrugs. "When I took a mind to do somethin', I always done it the best I could. I've always been that way. . . . I still am. I can't stand a guy that gives up and doesn't do anything." Even so, his spirit was nearly broken after his daughter Joan died in a freak accident where her car

Thirteenth Lake in North River, just up the road from Carl's place.

was struck by a snowplow driven by her own husband. "That was a hard time, that's for sure," he recalls grimly. When the pain of an empty home and its poignant memories became too great to bear, he moved up to his seasonal hunting and fishing cabin near Thirteenth Lake in North River, which became his new home.

Gradually, Carl's interest in music resurfaced, and for many years he was a local celebrity among the Adirondack bluegrass crowd. "I think his music and the good fishing saved his life," says his devoted other daughter, also named Mary Ellen. Although a severe neuropathy has silenced his instruments, Carl doesn't complain. He has a trout brook almost in his backyard, and his property, engulfed in the dense Adirondack forest, teems with deer, turkey, and other wildlife. At eighty-seven, he has long since made peace with life. When a huge tree next to his house was brought down by a storm a few years back, he insisted that the wood be cut into boards, and they still sit in his garage. On a recent home visit I asked him what he planned to do with them. He laughed when he said, "I think I'll build my own coffin. I can't let that wood go to waste!"

LEON LAMOREE

Indian Lake Shoe Salesman

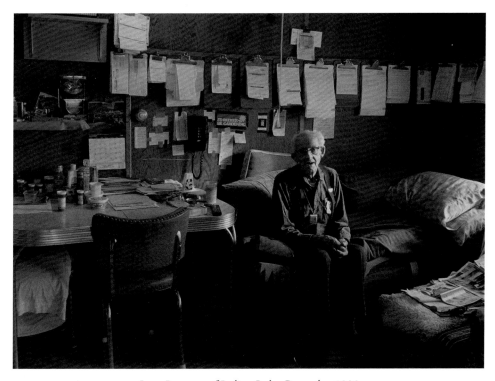

Leon Lamoree of Indian Lake, December 1989.

Leon was a gentle man who lived alone in a small cottage on Route 30 in Indian Lake. He somehow eked out a living selling shoes from his home and was well known in the community. In his later years, he developed a heart condition that frequently landed him in the hospital. When this would happen, his usually accommodating manner would be replaced by a rather impatient and demanding one. He would always insist on going home as soon as possible so that he could pay his bills, which would accumulate during his confinement. I found it hard to imagine why a few days delay would matter so much until I visited his home after one of his discharges from Glens Falls Hospital.

As this scene shows, paying his bills had become such an obsessive act that he had put all his monthly accounts onto separate clipboards so that he could refer to them at a moment's notice. He would jokingly say that having to pay his bills was what kept him alive, and I would jokingly reply that perhaps he shouldn't be in such a rush to get them all paid! One night when he was well into his eighties, he must have gotten them all paid up, and he died peacefully on his bed within reach of his beloved clipboards.

JOE MINDER

Former Japanese POW, North Creek

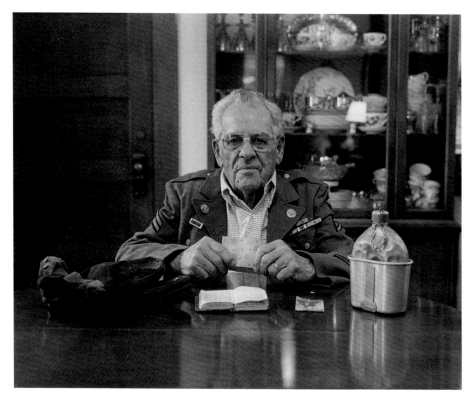

Joe Minder of North Creek with prison camp mementos, May 2000.

Like many American men his age, Joe Minder had little control over his destiny or even his immediate future when Japan bombed Pearl Harbor on December 7, 1941. Even so, he was less fortunate than most of his contemporaries to find himself that historic day on the western Pacific island of Luzon in the Philippines, under the command of General Douglas MacArthur. That's because, within twenty-four hours, the Japanese would launch an assault on the Philippines that ultimately resulted in the surrender of over 76,000 American and Philippine soldiers, including Joe Minder.

A native of North Creek, Joe had joined the United States Army seven months earlier as an engineer in Company A of the 803rd Aviation Engineers Battalion, whose purpose was to build landing strips wherever their skills were needed. Like many enlisted men who had a lot of free time on their hands, Joe kept a diary during his military career using shorthand to save paper and to discourage prying eyes. His entry on December 8, 1941, reads:

9:00 P.M. Paper just came in for Clark Field, "Hawaii Bombed! War Declared!" While we were eating dinner,

the first flight of Jap bombers went over our field to bomb Clark Field. Heard the explosions (of) oil dumps and ammunition dumps. . . . Several hundred killed and injured. Much of the 803rd Engineers equipment was destroyed. . . . I have been put on a machine gun. So far no Jap planes have come down close enough to get a shot at one.

Enemy land and air assaults on Luzon continued almost every day as the Japanese army pushed the beleaguered Americans to the southern end of the island, cut off from any hope of rescue or escape. As his entries vividly recounted, the American forces' situation became more desperate as time went on:

December 23: Japs have broken through the lines and are only a few miles from here. We are going to have to abandon this field and move. . . . Things are getting hot!

December 31, 1941: Bombed for the first time, as were eating supper. Koltoff almost had his leg blown off and two other men from my company were hit by shrapnel. Two large gas trucks were blown up across the road. Several Phillipinos were killed, and 12 were buried alive when a bomb landed near their shelter. Some of our men dug them out, but only two survived.

January 1, 1942, 11:00 A.M.: Japs bombed and strafed while we were working on the field. Got my first shots at a Jap plane when I emptied my rifle at one as it came in to strafe the field. Saw the plane catch fire and explode, when it hit the ground. 4:00 P.M. Japs spotted our foxholes and dropped frag bombs and strafed the heck out of us. One bomb landed about ten feet from the foxhole that John Delemater and I were in, knocking dirt on us.

January 2, 1942: Spent half the night blowing up dud bombs that the Japs dropped yesterday. Darn tired but will have to work like heck today, preparing to move again, to Bogani Road on Bataan. This will make the fourth field I have worked on, which they have captured.

January 23, 1942, 9:00 A.M.: First food and water since 4:00 A.M. yesterday. Fought 26 hours straight, with only one casualty. 2:00 P.M.: Many Jap snipers all around us. I almost got it when one spotted me and started firing at me before I got a chance to get my machine gun set up.

Looking toward North Creek from River Road, near Minder home.

It was so thick with vines that we had to cut our way through with our bayonets. We managed to keep pushing the Japs back toward the beach until about 5 P.M. at which time we ran in to crossfire from Jap machine gun nests. Before we could fall back, they broke through the line and killed and wounded about half of us. Robert Ray and Kenny, two close buddies of mine were the unfortunate ones. Thank God, they were both killed instantly and didn't have to suffer like some of the rest did. The Japs tried to cut the rest of us off, but we waited until dark and managed to sneak back through their lines.

The situation on the Bataan Peninsula became increasingly desperate with time, forcing Joe's unit to retreat to the fortified island of Corregidor in Manila Bay. Once there, things only went from bad to worse:

February 5, 1942: Arrived here about 4 this morning. Every place we go the Japs seem to follow us. Corregidor was shelled for the first time today. Several shells landed in our bivouac area.

Despite being hopelessly surrounded, starving, and subjected to constant bombardment, the American and Filipino forces held out for three more months before the inevitable happened:

May 5–6, 1942: Plenty fireworks to celebrate my birthday today. The Japs have shelling and bombing continuously since early this morning. All communications have been cut off from the other end of Corregidor. . . . Marines were forced to leave the beach when all of their machine guns were blown up, and they were blasted from their foxholes by Jap artillery. 11 P.M. For the past three hours there hasn't been a single break in the hundreds of shells which have hit this end of the island. 11:30 P.M. INVASION! Japs landed under heavy bombardment about an hour ago. Communications being cut off, no one but the men in the immediate area knew they had landed. A bunch of us loaded into a truck which had all the tires flat from shrapnel and made our way over a shell-blasted road to sit a machine gun on a small hill overlooking the beach and the airfield only 500 yards away—where the Japs have already advanced to. We managed to hold the Japs at this point, except for the few snipers who managed to filter through the gaps in our line. Artillery continued to blast away all night from Bataan, and there was a fierce exchange of machine gun fire between us. . . . 5 A.M. May 6. At first I thought I would be glad to see daylight, so we could see what we were doing, but when Jap planes started their daylight bombing and spotting for the artillery from Bataan I soon changed my mind. With the cover of darkness gone, it was impossible for us to fire without being spotted by the hundreds of snipers who had by this time stationed themselves all over the island. 8 A.M. By this time we had suffered many losses; however, we managed to continue holding the main force of the Japs until they started landing tanks. With no guns left to combat the tanks we were forced to surrender at noon. Then is when I received the bad news of Drake's and Bailey's deaths, two very close buddies of mine. The last time I saw Bailey was about midnight when he and I were firing at a Jap sniper from the same bomb hole. Dead tired, sweaty, dirty with cuts and bruises from diving into shell holes and going through the brush, I climbed on top of a stack of empty ammunition boxes and slept until 5 o'clock at which time the Japs came and stripped us of most of our belongings.

As a POW, his first duty was to bury the bodies of his dead comrades, which he found "almost unbearable." Despite his predicament, Joe was fortunate in some ways. Because he was captured on Corregidor instead of Luzon's Bataan peninsula across the harbor, Joe and his fellow GI's were taken to the infamous Cabanatuan prison camp by ship and thus avoided the horrific Bataan Death March where over 10,000 starving, sick GIs died at the hands of their captors in a forced march to Cabanatuan. He also had the presence of mind to hold onto his army-issue canteen and cup, which gave him a way to gather and save meager amounts of food and water. "That mess kit saved my life," he told me.

His captors discouraged the keeping of personal effects, but Joe was able to keep a stubby pencil and a tiny bible hidden on his person throughout his captivity. Using Japanese cigarette paper, he maintained his shorthand diary as a way to keep his sanity. Even after sixty years, his entries are painful to read:

October 29 to November 11, 1942: Food scarcer than at any time so far. 50 men to a bucket of rice. Our camp is located in the center of huge rice paddies with swamp land all around us. The flies and mosquitoes are terrible. Two months ago they had a death rate which averaged 30 or more dying every day.

November 12 to November 29, 1942: Chief Anderson and several other men from my company died. Volunteered for burial detail and have been carrying out men at the rate of 15 per day for the past two weeks. The first day was rather rough . . . the expression on some of their faces was horrifying. . . . Thank God the mothers of these poor boys can't see any of these terrible sights.

January 21 to May 1, 1943: The Japs must be suffering heavy losses by the way they are treating us now. They have cut down on our food again and have started beating the heck out of us. . . . Every time we look around some one is getting a cruel beating for some darn thing. I got hit in the head by a bayonet, crushing my sun helmet and putting a lump on my head which I carried for a week.

The months turned to years, all the while watching his fellow POWs dying of every conceivable cause from disease to starvation to murder at the hands of his captors. It is hard to imagine how Joe

North Creek from Route 28.

had the physical and emotional strength to cope with the despair and hopelessness of his situation. However, on September 21, 1944, Joe and his surviving colleagues were given some reason to hope for deliverance.

Planes! Planes! American planes! All heck broke loose directly overhead when the Americans slipped in through the clouds, contacted Jap planes, and started severe dog-fights all around us. We ran from the field to a mango grove and saw what we have been waiting for. The dog-fight lasted for an hour during which time we saw the Yanks shoot down 1 large transport plane and sent several Jap planes away smoking. With all the Jap planes driven off, our Grumman Navy planes started diving on Nicklas Field and other military objectives, strafing and bombing with no opposition at all. Several stray 20-mm shells landed near us, but we were so darned excited we didn't even go for a hole!

Unfortunately, Joe's hopes were dashed only ten days later.

October 1, 1944: Oh what misery! 741 of us are packed into the forward hold of a small crummy coal cargo ship, sitting here in Manila Bay waiting to be shipped to Japan. We are packed into a small space of about 35 by 50 feet almost on top of one another. At 6 P.M. several old letters were brought aboard from Manila. Most of them have been here for months. I received several Xmas cards sent from people in North Creek in December 1943 and some letters from home. One had a nice picture of Ma and Dad. I know this is going to be hell, staying down here in this cramped position for 12 days but after seeing those pictures and reading those letters and cards I don't feel quite so bad.

Now the men had a new fear to deal with, "friendly" fire:

October 9, 1944: 10 men have already died and have been thrown overboard. We thought we might be some more shark bait a few minutes ago when a Yank sub fired a torpedo at us, barely missing the bow of the ship and sinking an oil tanker along side of us. When the Japs started dropping depth charges, it sounded like the sides were collapsing in on us.

His twelve-day trip turned into a six-week night-mare before reaching landfall.

November 8, 1944: Just got on shore. Most of us are so weak we can hardly walk. During that 39 days of hell, cramped up in that crummy hole, we lost 38 of our men. The rest of us who managed to survive have lost many pounds. God what looking men! With a 39-day beard, dirty, pale and skinny we all look like walking skeletons coming out of a dungeon.

For the next nine months, Joe performed slave labor in a copper mine in northern Japan, where the men had to endure a cold winter and dwindling food supplies. All he had to protect his feet from the snow and sharp stones in the mine were some poorly made canvas shoes. As the last days of the war approached, his captors would occasionally show some measure of kindness toward the men.

April 4, 1945: Received one American Red Cross food parcel per man. I enjoyed this better than any other chow that I have ate in my life.

Some of this generosity was more out of necessity than kindness.

July 11 to August 14, 1945: More air raids every day now. Getting soy beans in small amounts. We got so weak last month and so darn many men passed out on the job that the Japs realized they wouldn't be able to get any more work out of us unless our diet was picked up a bit. No one has gained any weight but at least we aren't passing out on the job anymore.

Finally, the moment the men thought would never come was at hand. It left Joe almost speechless:

August 20, 1945: War's end was officially announced by interpreter Mosiki at 1:15 P.M. Still hard to believe!

It took three months for Joe to recover from his ordeal enough to return home. When he returned to civilian life, Joe converted his cryptic notes into a thirty-one-page typewritten journal, which he was kind enough to share with me some years ago. Reading it reminded me why Tom Brokaw called Joe's The Greatest Generation, and moved me to ask him if he would let me photograph him with the few belongings he saved from his internment in Japan. In the coziness of his immaculate North Creek home he displays the canvas shoes he wore in the copper mines, his tiny bible, an image of the Madonna, and the mess kit that saved his life. In his hands is a sheet of the Japanese cigarette paper on which he kept his shorthand journal. On it he wrote his first peacetime entry, which rings as true today as it did in 1945:

August 22, 1945: After $3^1/_2$ years of starvation and brutal treatment, that beautiful symbol of freedom once more flies over our head. Our camp tailor worked all night and finished our first American Flag. The blue came from a GI barracks bag, red from a Jap comforter, and the white came from an Australian bed sheet. When I came out of the barracks and saw those colors for the first time, I felt like crying. I know now, like I never did before, what it means to be able to live in a peaceful nation like the U.S.A. with its unlimited amount of liberties and freedom.

ONE LAST VIEW

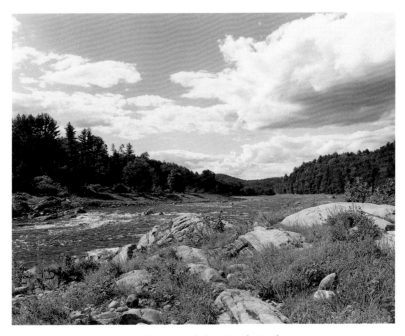

Hudson River below North Creek.

This view of the Hudson below The Glen is well known to locals as a popular site for camping, swimming, and picnicking. I like to stop here during my commute to or from work on days when I need a moment of solitude to clear my head. Although it is only a two-minute walk through the woods from the River Road just below Route 28, this spot is far enough from civilization to feel very peaceful and remote.

I remember sitting on these ancient granite rocks on August 16, 2000. It was my son Andy's twentieth birthday, and I was contemplating the fact that I had been a father for twenty years. The next day I would take both Andy and his only sibling Emily to college at Penn State University, where Andy would be starting his junior year while Emily was beginning her freshman year. I could not believe that in a few days Harriet and I would be look-

ing at an empty nest for the first time since we had become parents, and I could already feel the ache that would never completely leave. So there I sat, feeling rather sorry for myself.

Somehow, the gentle murmur of the Hudson's waters rushing past my toes, coupled with the fresh breeze coming down the river and the timeless view of tall pines and billowing clouds, were a welcome balm to my troubled spirit. Knowing that the silent gray rocks under my feet, worn smooth by eons of grinding ice floes, had endured for over a billion years made my fleeting insecurity seem trivial indeed. I felt a little better.

As I got up to return to the modern world, I looked back one more time to take in this very scene. It was comforting to know that it appeared exactly as in this photograph—which I had taken fifteen years earlier.

BIBLIOGRAPHY

Seneca Ray Stoddard

Adler, Jeanne Winston. *Early Days in the Adirondacks: The Photographs of Seneca Ray Stoddard.* New York: Abrams, 1997.

Crowley, William. *Seneca Ray Stoddard: Adirondack Illustrator.* Blue Mountain Lake, N.Y.: Adirondack Museum and Canterbury Press, 1982.

DeSormo, Maitland. *Seneca Ray Stoddard: Versatile Camera Artist.* New York: Adirondack Yesteryears, 1972.

Glens Falls Historical Society. *Bridging the Years: Glens Falls 1763–1978.* Glens Falls, N.Y.: Glens Falls Historical Society and Crandall Library, 1978.

Horrell, Jeffrey. *Seneca Ray Stoddard: Transforming the Adirondack Wilderness in Text and Image.* Syracuse: Syracuse Univ. Press, 1999.

Hudson River School

Howat, John K. *The Hudson River and Its Painters.* New York: American Legacy Press, 1972.

Yaeger, Bert D. *The Hudson River School: American Landscape Artists.* New York: Smithmark, 1996.

Adirondack Landscape Photography

Barnett, Lincoln. *The Ancient Adirondacks.* New York: Time-Life Books.

Clifton, Carr. *The Hudson: A River That Flows Two Ways.* Englewood, Colo.: Westcliffe, 1989.

Farb, Nathan. *The Adirondacks.* New York: Rizzoli, 1985.

———. *100 Views of the Adirondacks.* New York: Rizzoli, 1989.

Healy, Bill. *The Adirondacks: A Special World.* Utica, N.Y.: North Country Books, 1986.

Heilman, Carl E. *Adirondacks. Views of an American Wilderness.* New York: Rizzoli, 1999.

Kaplan, Barry. *New York: The Empire State.* New York: Skyline Press, 1984.

Ketchum, Robert Glenn. *The Hudson River and the Highlands.* New York: Aperture, 1985.

Lourie, Peter. *Hudson River: An Adventure from the Mountains to the Sea.* Honesdale, Pa.: Caroline House, 1992.

Porter, Eliot. *Forever Wild: The Adirondacks.* Blue Mountain Lake, N.Y.: Adirondack Museum and Harper & Row.

Smith, Clyde H. *The Adirondacks.* New York: Viking Press, 1976.

———. *New York: The State.* Dublin, N.H.: Foremost, 1986.

Winkler, John E. *A Bushwhacker's View of the Adirondacks.* Utica, N.Y., 1995.

Landscape Photography

Adams, Ansel. *Yosemite and the Range of Light.* New York: Little, Brown, 1979.

Cahn, Robert. *American Photographers and the National Parks.* New York: Viking Press, 1981.

Horan, James D. *Timothy O'Sullivan: America's Forgotten Photographer.* New York: Bonanza, 1966.

———. *Matthew Brady: Historian with a Camera.*

Muench, David. *American Landscape.* New York: Arrowwood Press, 1987.

Rowell, Galen. *Mountain Light.* San Francisco, Calif.: Sierra Club, 1986.

Thornton, Gene. *Landscape Photography: The Art and Technique of Eight Modern Masters.* New York: American Photographic Book Publishing, 1984.

Other Photography

Armor, John, and Peter Wright. *Manzanar: Photographs of Ansel Adams.* New York: Times Books, 1988.

Goldberg, Vicki. *Lewis W. Hine: Children at Work.* New York: Prestel, 1999.

Hine, Lewis W. *Men at Work.* New York: Macmillan, 1932.

Langer, Freddy. *Lewis W. Hine: The Empire State Building.* New York: Prestel, 1998.

Loranz, Richard. *Imogen Cunningham: Ideas Without End—A Life in Photography.* San Francisco: Chronicle, 1993.

McCurry, Steve M. *Portraits.* London: Phaidon, 1999.

Norman, Dorothy. *Alfred Stieglitz: An American Seer.* New York: Aperture Books, 1973.

Oppersdorff, Mathias. *Adirondack Faces.* Syracuse: Syracuse Univ. Press and The Adirondack Museum, 1991.

Thompson, Jerry L. *Walker Evans at Work.* New York: Harper & Row, 1982.

Van Haaften, Julia. *From Talbot to Stieglitz: Masterpieces of Early Photography from the New York Public Library.* New York: Thames & Hudson, 1982.

Compassion Fatigue

Figley, C. R., ed. *Compassion Fatigue: Coping with Secondary Traumatic Stress Disorder in Those Who Treat the Traumatized.* New York: Brunner/Mazel, 1995.

Gilley, K. *The Alchemy of Fear.* Boston: Butterworth-Heinemann, 1998.

———. *Leading from the Heart.* Boston: Butterworth-Heinemann, 1997.

Maslach C., and M. P. Leiter. *The Truth about Burnout.* San Francisco: Jossey-Bass, 1997.

Pfifferling, John-Henry, and K. Gilley. "Overcoming Compassion Fatigue." *Family Practice Management* 7 (April 2000): 39–44.